Terry Harrison

Watercolour Mountains, Valleys & Streams

SEARCH PRESS

First published in Great Britain 2006

Search Press Limited
Wellwood, North Farm Road,
Tunbridge Wells, Kent TN2 3DR

Text copyright © Terry Harrison 2006

Photographs by Roddy Paine Studios
Photographs and design copyright © Search Press Ltd. 2006

All rights reserved. No part of this book, text, photographs
or illustrations may be reproduced or transmitted in any
form or by any means by print, photoprint, microfilm,
microfiche, photocopier, internet or in any way known
or as yet unknown, or stored in a retrieval system,
without written permission obtained beforehand from
Search Press.

ISBN 1 84448 100 X

The Publishers and author can accept no responsibility for
any consequences arising from the information, advice or
instructions given in this publication.

Suppliers
If you have any difficulty obtaining any of the materials and
equipment mentioned in this book, please contact
Terry Harrison at:

The Terry Harrison Gallery, 28 Cove Road, Cove,
Farnborough, Hampshire GU14 0EN, United Kingdom

Telephone: +44 (0)1252 545012 / 545071

Website: **www.terryharrison.com**

Publishers' note
All the step-by-step photographs in this book feature the
author, Terry Harrison, demonstrating how to paint with
watercolours. No models have been used.

Manufactured by Universal Graphics Pte Ltd, Singapore

Printed in Malaysia by Times Offset (M) Sdn Bhd

*To my wife, Kate and my daughters, Amy and Lucy.
In addition, to my new Tibetan Terrier puppy – an
adorable menace called Poppy.*

*With thanks to Kate who helps to keep the business going on the
home front, both our Gallery and mail order service – ably assisted by
her brother and sister, Derek and Judy Whitcher, as well as our
invaluable framer and assistant Daniel Conway, an artist in
his own right.
I am also indebted to the many helpers who assist me at the art and
craft shows across the country – they are dedicated workers and have
to tolerate my endless 'witty' patter!
Many thanks go to Sophie Kersey, my editor, for patiently
transcribing my latest artistic offering and for knowing what I wanted
to say when I didn't know myself!*

Cover
The Secret Valley
460 x 670mm (18¼ x 26½in)
*This painting shows the use of masking fluid on the
mountains, scraping out on the bridge and the credit
card technique on the rocks. The texture on the trees
has been created by the stippling technique.*

Page 1
The Packhorse Bridge
500 x 670mm (19¾ x 26½in)
*The photograph from which this painting was taken
showed a summer scene. I changed the season to
winter so that the mountains in the background are
more visible. The purple shade of the mountains,
reflected in the water is complemented by the warmer
tones of raw sienna, creating a warm and
harmonious picture.*

Opposite
The Forgotten Falls
170 x 500mm (6¾ x 19¾in)
*I visited this waterfall on a very wet day, in
unsuitable shoes and with a very small umbrella.
After half an hour's walk I was rewarded with the
view you see in the painting. I love the way the water
dramatically changes direction as it
cascades down the slope.*

Contents

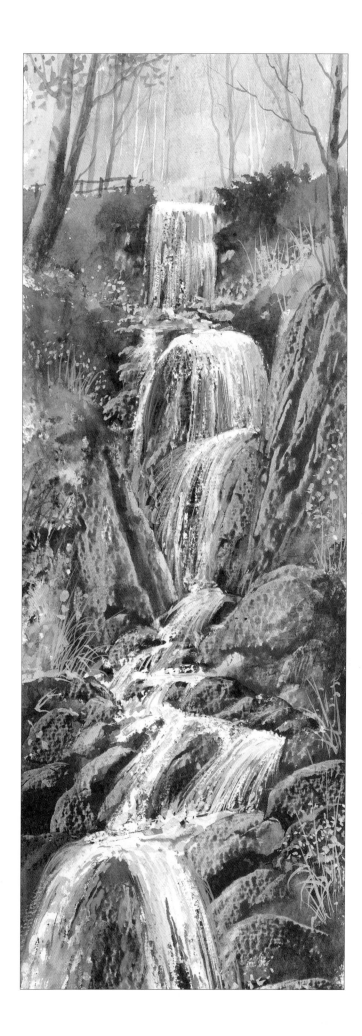

Introduction

I am not very good with heights, so it is surprising that I would want to tackle a book on how to paint mountains. However, most people who want to paint mountains are not mountaineers. Like many people, I have a love of mountain scenes, even though the last thing I want to do is climb up one. As a youngster I went on a school trip to the Lake District, which entailed hiking over mountains from youth hostel to youth hostel. I now look back on this fondly, but at the time I'm sure the experience was clouded by painful blisters and the burden of an overloaded rucksack.

In this book I demonstrate how a non-geologist can create realistic looking mountain scenes.

Inevitably with mountains you get valleys, and at the bottom of a valley there is usually a river or stream, so the three elements are closely linked. If you are looking for inspiration and reference for painting valleys and streams, the easy bit is going down to find your subject; unfortunately the down side is that you then have to climb back up. Once you have your reference material such as photographs or sketches of mountains, waterfalls, bridges and different rock formations, you have the basis for producing your own composition.

Over the years I have developed lots of techniques (short cuts) for painting many different subjects in watercolour. In this book, I have collected together the techniques best suited to painting mountains, valleys and streams. They include using masking fluid, paper masks, wet in wet and scraping out. Once you have mastered these simple techniques, you can then move on to paint virtually any subject you choose.

Many of the paintings in this book are painted on textured paper, and the texture is used to great effect when painting mountains and rocks with the credit card technique I have developed. This technique came about by accident, when a student of mine said that she saw someone paint a tree trunk using a credit card. I tried this, but with disastrous effects: because all the tree trunks looked like rocks. With a bit more practice, the credit card rock technique was developed, and it is explained in detail in this book. I eventually mastered the tree trunk technique, so this is also included.

This book should be a great comfort to armchair mountaineers – knowing that they can produce wonderful mountain scenes without actually leaving the studio.

Terry Harrison

Lakeland Reflections
420 x 560mm (16½ x 22in)
I wanted to capture the reflections in the lake in this scene. The stones in the foreground add impact by leading the eye into the picture.

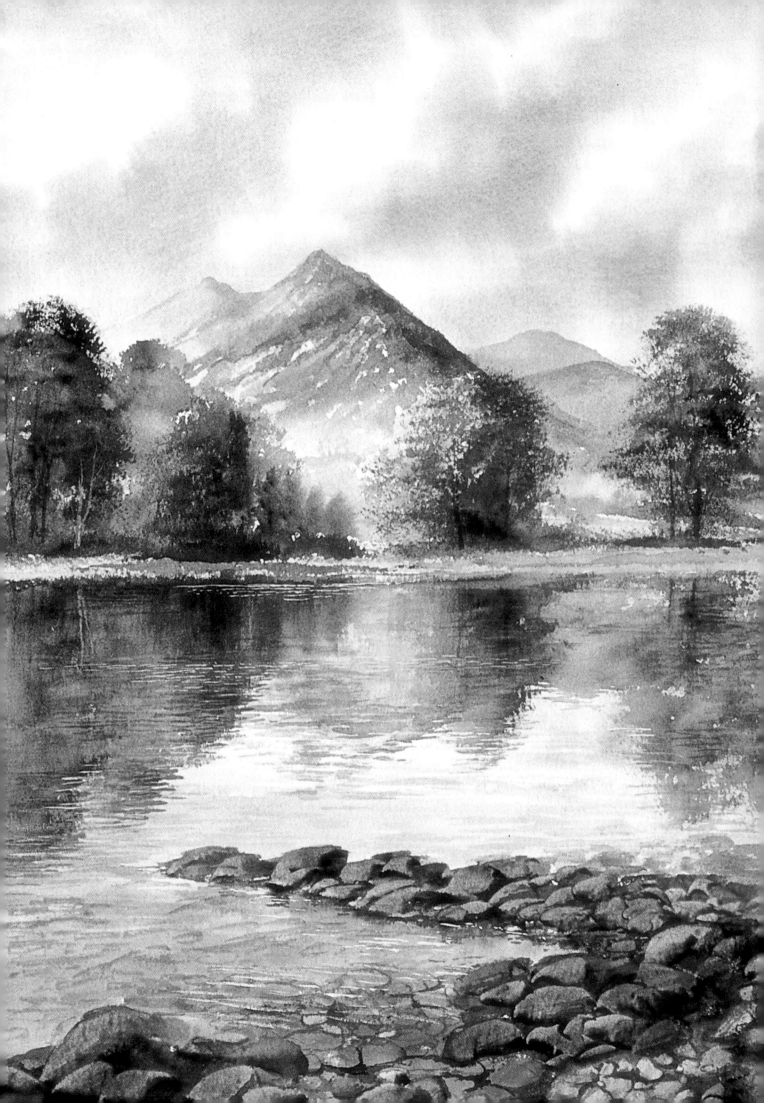

Materials

You will need a range of brushes and a selection of paints. I have used only one type of paper in this book, but you can try different weights and textures.

Paints

Watercolour paints come in artists' or students' quality. I always use artists' quality colours because they flow and mix better and give the best results. You should buy the best paints you can afford. There is a lot you can do using only the primary colours and a limited palette, but there are many other colours available if you want to experiment.

Brushes

Many artists adapt brushes to suit their requirements. I have gone a step further and produced my own range of brushes that I have used throughout this book. They are designed to help you achieve good results easily. Pages 14–15 show how the individual brushes can be used to achieve various techniques I use to paint mountains, water, sky, trees, rocks and stonework.

Paper

Watercolour paper comes in different weights and in three surfaces: smooth (called hot-pressed or HP), semi-smooth (called Not) and rough. I usually use 300gsm (140lb) rough paper, because the texture is useful for many techniques I use. When I am painting in more detail, I use Not paper of the same weight, because the smoother surface is better for more detailed work.

Stretching paper

I never bother to stretch paper before painting. If a painting cockles as it dries, turn it face down on a smooth, clean surface and wipe the back all over with a damp cloth. Place a drawing board over it and weigh it down, then leave it to dry overnight. The cockling will disappear.

Other materials

Hairdryer
You can use this to speed up the drying process.

Masking fluid
This is used to preserve the white of the paper to achieve many affects such as snowcapped mountains or ripples in water.

Ruling pen
This can be used with masking fluid when you need to paint fine strokes, for instance when painting grasses.

Masking tape
I use this to tape paintings to my drawing board.

Pencil and sharpener
I use a 2B pencil for sketching and drawing, and always keep it sharp.

Eraser
I use a hard eraser to remove masking fluid and to correct mistakes – sorry, I should say to enhance my drawing.

Credit card
Use an old plastic card for scraping out techniques when painting mountains, rocks and trees (see pages 18–19).

Kitchen paper
This can be used to lift out wet paint, for instance to suggest highlights when painting clouds.

Soap
This is used to protect your brushes from masking fluid. Wet the brush and coat it in soap before dipping it in masking fluid. The masking fluid is then easily removed afterwards.

Easel
I have been using this easel for about twenty years. It finally gave up the demonstration circuit with a spectacular collapse at a show shortly after we photographed it for this book. I have used the good bits from it together with another easel, and I now have a reborn easel. It is called a box easel (though at the time of its demise, I called it something else). It is a sturdy painting platform at which you can stand, or you can fold the legs away and use it on a table top. There is a slide-out shelf that holds your palette.

Bucket
You need to rinse brushes properly if you want them to last. I use a large bucket so that I always have enough water to hand.

My palette

I am not a great fan of a limited palette, but having said that, I do limit myself to a relatively small selection of colours. In my palette I have a selection of colours that can be used for virtually any painting I choose to paint. The colours I use are shown on the right. Using combinations such as alizarin crimson and cobalt blue, you can create fabulous distant hills. Ultramarine and burnt umber is a great alternative to using black or grey. By using more blue you get a cooler colour, and by using more burnt umber you get a warmer colour. Adding raw sienna to a grey mix creates the effect of sunlight on the side of a mountain. The colour shadow is a fresh, transparent colour that can be mixed with others or used in its own right. It is used to great effect in many of the paintings in this book.

The colours I use
With this range you can mix most colours.

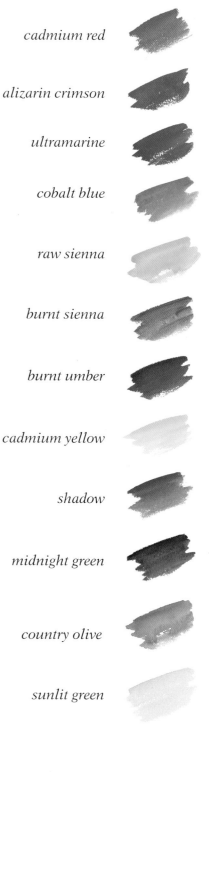

cadmium red

alizarin crimson

ultramarine

cobalt blue

raw sienna

burnt sienna

burnt umber

cadmium yellow

shadow

midnight green

country olive

sunlit green

Useful mixes

In this section, I have put together a selection of colour mixes that are suitable for painting a variety of mountain scenes as well as foliage and vegetation. These are fairly basic mixes that you will find useful for painting many other subjects.

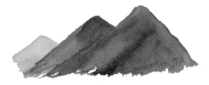

Ultramarine and burnt umber make a useful grey which is excellent for painting rocky mountains. More blue can be added for the shadowed areas, and more burnt umber for sunlit parts. A paler, bluer mix of the same colours is ideal for more distant mountains.

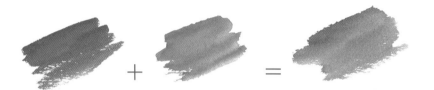

Alizarin crimson and cobalt blue also make a good purple mix for distant mountains. Once again, those furthest away can be made bluer, since the cooler shade suggests distance.

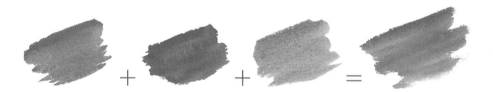

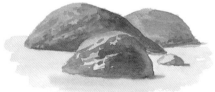

Alizarin crimson, cobalt blue and burnt sienna is a useful mix for painting rocks. Make a paler, browner mix for the sunlit parts of the rocks and use a darker, bluer mix for the shadowed areas.

Cobalt blue and midnight green is a good mix for distant valleys and grassy mountains. Hedgerows in the valley can be applied using a greener version of the mix. Once again, more distant mountains should be bluer.

Warm colours

Using different colours can create a variety of atmospheres. In the painting shown, I have used a selection of colours such as alizarin crimson mixed with raw sienna to add pink to the sky. Raw sienna and burnt sienna are used for the sunlit mountainsides. This is enhanced by the use of cooler shades on the shadowed sides of the mountains and in the valley. Although the predominant colours in the valley are blues and greens, there are still splashes of warmth created by similar colours to those used on the mountainsides.

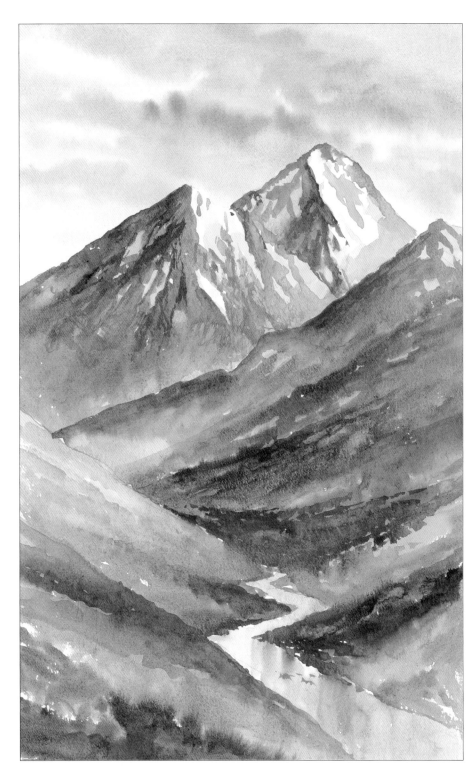

Approaching Sunset
350 x 520mm (13¾ x 20½in)
The dominant colours in this painting are the warmer shades, but these are highlighted by the use of some cooler colours for contrast.

Cool colours

The dominant colour in this painting is blue, which is the ultimate cool colour. The mountains were painted using the scraping out technique and cobalt blue and ultramarine blue. The darker shades of blue contain a hint of burnt umber. Coming forwards, the fir trees were painted mainly with blue, but with midnight green added. The rock formations on either side of the river were painted using the scraping out technique. The colours used were ultramarine blue with burnt umber. The warmer colours in the foreground and the cooler shades in the background help to create the illusion of distance.

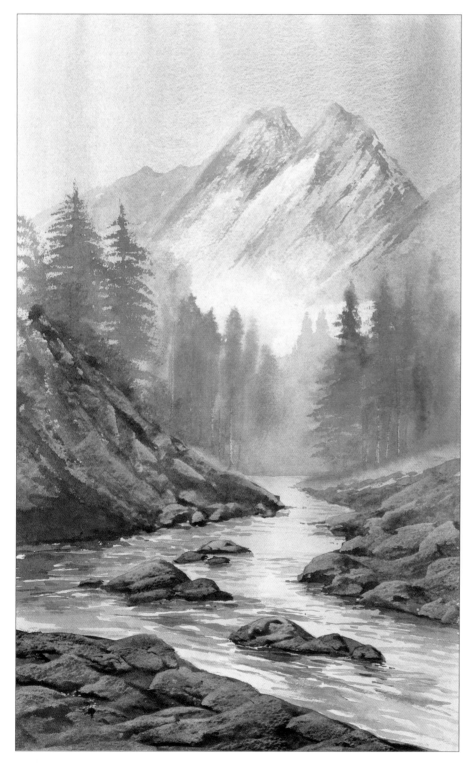

Cool Waters
320 x 510mm (12¾ x 20in)
The chill of the mountain air is suggested by the use of cool blue shades, contrasted by the slightly warmer tones in the foreground.

Using photographs

When you are producing a painting, good reference material is essential. Not everyone has the good fortune to travel the country sketching, but a good alternative is the use of photographs, either your own or ones from books or magazines. You can pick out an interesting section of a photograph and combine it with elements from others to create an ideal scene. In this way you can remove parts of the scene that you simply don't want to use.

In my experience, most artists use photographic reference, so there is no need to feel that you must climb a mountain in order to paint one!

Care must be taken when using reference from books and magazines that might be covered by copyright laws. If you are using a 'how to paint' book such as this one, this is not a problem. Feel free to copy any of the images in this book. However, if you do copy another artist's work and then offer your painting for sale, you should credit the artist by saying, for example, 'after Terry Harrison' or 'in the style of Terry Harrison'.

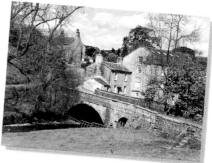

I have used the buildings and the bridge from this scene, but have removed the trees.

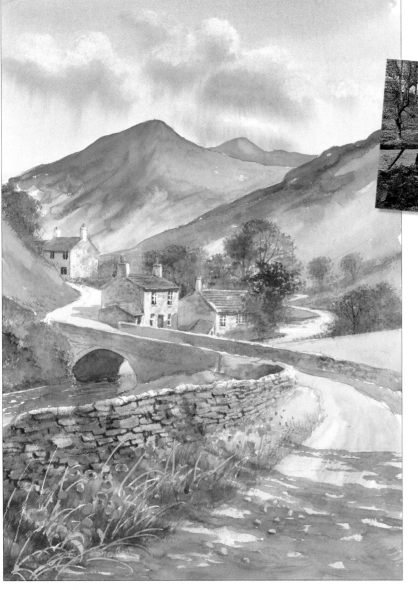

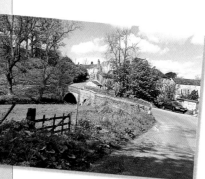

The foreground shadows and the road were taken from this photograph.

In this painting, which appears as a project on pages 44–53, I used elements from both reference photographs and added the mountains in the distance and the continuation of the stream, leading the eye into the scene.

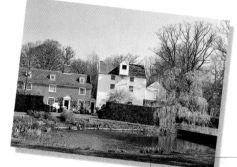

I photographed this delightful mill on a visit to Suffolk. What caught my eye was the contrast between the white of the mill and the mellow colours of the mill house.

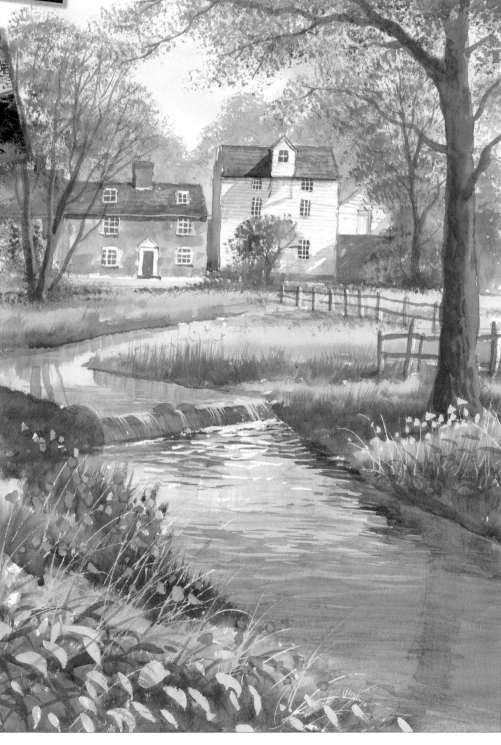

The mill stream and little waterfall taken from this photograph are used as a device to lead the eye into the painting. This stream does lead from the mill shown but the photograph was taken from a different angle. The two views were combined to create an idyllic scene. This is called 'artistic licence'!

The focal point of this painting, which appears as a project on pages 54–63, is the mill buildings. The flowers create interest and colour in the foreground.

Techniques

Using the brushes

You can create wonderfully realistic effects using just the range of brushes shown here.

Large detail

This brush is useful for washes as it holds a lot of paint. For large areas of colour, use a sweeping, horizontal motion from side to side and from top to the bottom.

Flat brush

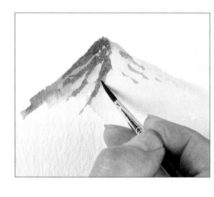

The 19mm (¾in) flat brush is useful for washes and for water. To create a rippled effect, brush it from side to side to produce horizontal lines.

Medium detail

This is ideal for smaller details. Paint the outline of the mountain and then fill in the shape, adding more water to the mix when necessary.

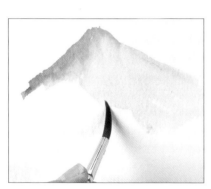

Small detail

This brush is useful for really delicate work. Add the shapes of the rock formations wet on dry using a strong mix of ultramarine and burnt umber.

Half-rigger

The half-rigger has a really fine point but holds a lot of paint. The hair is long, though not as long as a rigger. It is excellent for adding very fine details wet on dry. Use an upwards flicking motion to create reeds, as shown here.

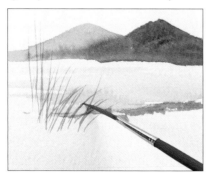

Golden leaf

A large wash brush, ideal for skies. Sweep a wet mix of blue across the paper, then add ultramarine and burnt umber wet in wet to paint clouds.

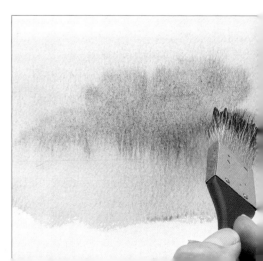

Foliage brush

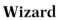

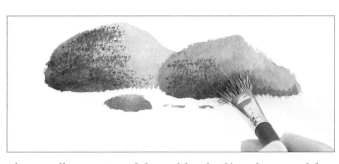

This smaller version of the golden leaf brush is good for stippling. Paint rocks with a flat wash and let it dry. Then, using a fairly dry brush, stipple with the ends of the bristles to create texture.

Fan stippler

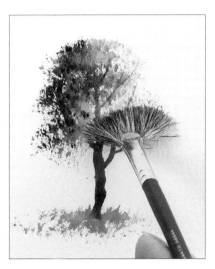

This is a fan-shaped version of the foliage brush, and is ideal for trees. Stipple in green, then stipple a deeper green on top for foliage.

Wizard

Twenty per cent of the hair in this brush is longer than the rest, which produces some interesting effects. To create reflections, apply a light wash, then take the dark colour and drag it down wet in wet. Only a little paint comes out of the brush, producing a useful streaked effect.

Fan gogh

This thick fan brush holds lots of paint and is excellent for trees. Paint the background trees and leave to dry. Use the curve of the brush to add the fir tree, then flick up to create grasses.

Fan gogh px

This version of the fan gogh has a clear handle that is great for scraping out stonework. First apply raw sienna, then light green, not too wet. Paint a dark colour such as ultramarine and burnt umber on top of the first colour. While it is wet, scrape out shapes for stones with the shaped end of the brush handle.

15

Washes

Washes need to be done quickly and with confidence, but this does not mean rushing, so don't panic. Watercolour does not dry as quickly as you would imagine. To avoid streaks in a wash, a good tip is to wet the background with some clean water and paint the wash wet into wet. You must use a large brush that will hold plenty of liquid so that you do not need to reload it too often.

Skies

Use the golden leaf brush to apply a wash of ultramarine, adding more water as you go down the paper. Then make a thin mix of ultramarine and paint a cloud wet in wet. Use a slightly stronger mix to create a shadow under the cloud, still painting wet in wet.

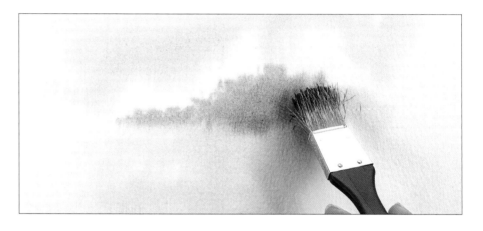

Mountains

Mix a blue wash from ultramarine with a little burnt umber and use the large detail brush to paint the distant mountain. Then make a darker version of the mix to paint the outline of the mountain in front of the distant one. Fill in the shape.

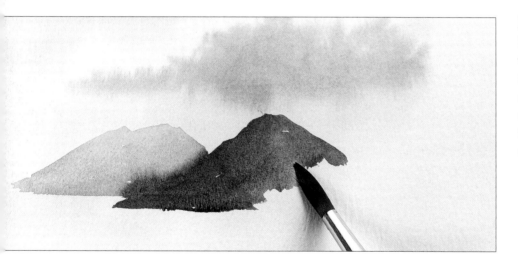

Water

Make a thin wash of ultramarine to reflect the sky colour and use the 19mm (¾in) flat brush to paint the water. Use the horizontal line of the brush to create a rippled effect, moving the brush from side to side as shown.

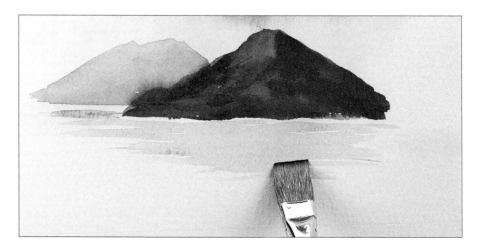

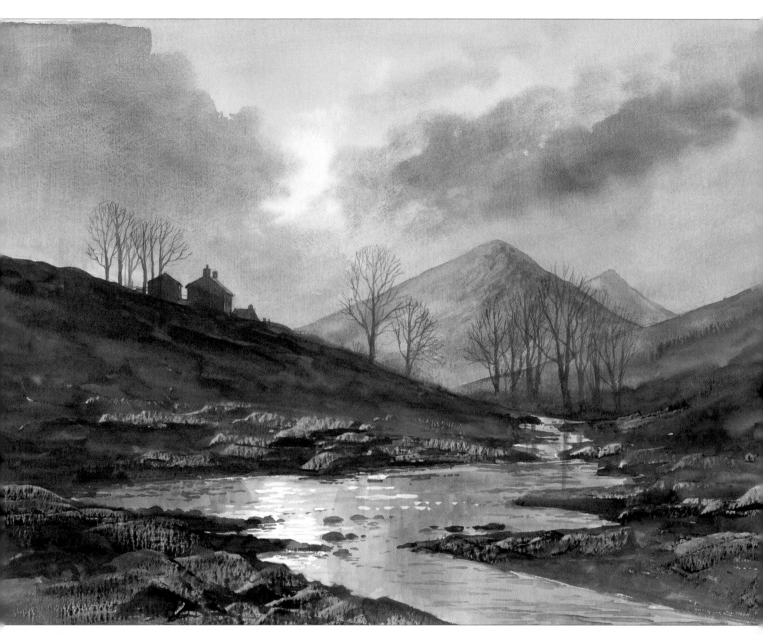

Gathering Storm

500 x 350mm (19¾ x 13¾in)

This painting uses the wet into wet technique, but each section was allowed to dry before the next was started. The sky was painted first using a warm wash of raw sienna, then the darker cloud colours were dropped in wet into wet. The sky was then allowed to dry. The mountains were painted next. If they had been painted on to a wet background, they would have dissolved into the wet paint. The stronger mix for the middle distance, creating the dark silhouette of the buildings, was also used for the winter trees. The foreground was painted next using the scraping out technique to create the rock formations. Finally, when that was dry, the water was painted, reflecting the colours used in the sky.

Scraping out using a plastic card

This technique can be used to create effective textures. The effects created in this book, suggesting mountains, rocks and tree trunks, require a rough surfaced paper. By scraping the paint off the raised part of the rough paper, you can create the lighter shades of the rocks or mountains. The darker tones are suggested by the paint left in the indentations.

The key to this technique is the uneven pressure applied to the plastic card, allowing more paint to be scraped off the surface where you want the tone to be lightest. If the light is on the left-hand side of the rock or mountain, hold the card towards the left-hand edge, and this is where the most pressure will be applied. There will be less pressure on the trailing edge, so less paint will be removed. The paint needs to be applied fairly thickly, as if it is too wet, it will flow back over the paper. Practise this technique before attempting a painting.

Mountains

The trick with this technique is to scrape the paint off with a quick, sharp movement.

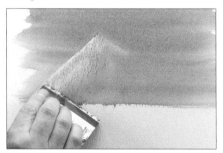

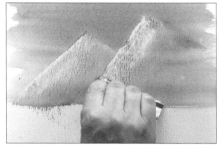

1. Apply a wash using the golden leaf brush. Then scrape diagonally across it with the plastic card to create a mountain.

2. Scrape out a second mountain in front of the first. Allow the painting to dry.

3. Use the large detail brush and shadow colour to add detail, giving shape to the rock formations.

Rocks

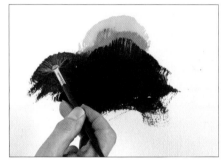

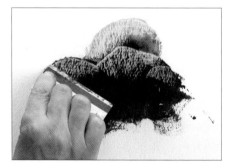

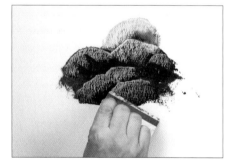

1. Use the fan stippler to paint on layers of thick, dryish paint for the rock formation, going from light to dark. First paint on raw sienna, then burnt sienna, then burnt umber mixed with ultramarine. Lastly paint on midnight green to add interest.

2. Starting at the back of the rock formation, scrape out rock shapes with the plastic card. Using extra rough paper helps to create a rocky texture.

3. Continue in the same way to the bottom of the rock formation, scraping paint off the surface to leave darker colour in between the rock shapes, suggesting shadowed crevices.

Tree trunks

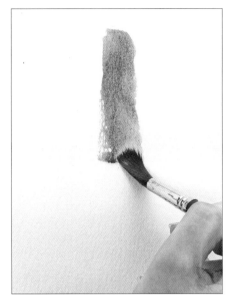

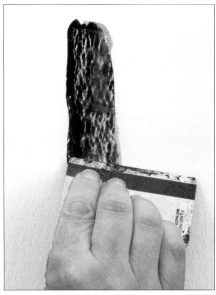

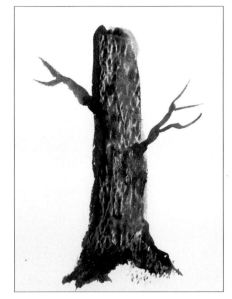

1. Paint the trunk with a light green wash of raw sienna and sunlit green.

2. Paint country olive over the top, and then burnt umber and ultramarine. While the paint is wet, scrape the card straight down the trunk.

3. Use the large detail brush to add branches and roots to complete the tree trunk.

Scraping out using a brush handle

Whatever base colour a wall is, for instance a warm sandstone shade or a harsh granite colour, you need to paint this on first. In the example shown, I have used raw sienna and then green to give the impression of a mossy, mellow wall. This colour stains the paper, then you put the dark colour on top. Before it dries, scrape the dark colour off the top to expose the colour underneath. Scraping pushes the top colour aside, creating a dark outline to each stone.

Stone walls

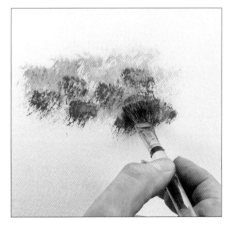

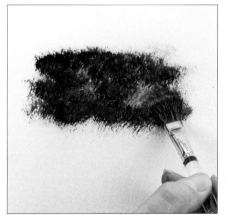

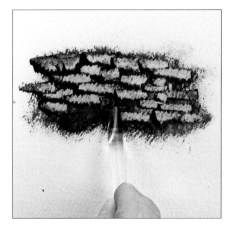

1. Use the foliage brush and thick raw sienna paint to dab on texture. Then scumble sunlit green on top.

2. Scumble a darker mix of ultramarine and burnt umber on top. Make sure it is not too wet.

3. Before the paint dries, scrape off stone shapes in the wall using the scraper end of the fan gogh px brush.

Using masking fluid

Many artists do not like using masking fluid because it ruins brushes – see the tip! Once you have mastered the art of using masking fluid, it gives you the opportunity to create all sorts of different effects. The obvious effect when painting mountains is the snowcapped peaks. When using masking fluid, you need only mask out the lightest areas. Another application for masking fluid is the sparkly effect of sunlight on water, and the white foam of a waterfall.

Tip
Before using masking fluid, wet the brush and wipe it over a bar of soap. You will then be able to wash the masking fluid out of the brush when you have finished.

Snowcapped mountains

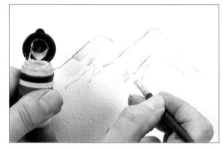

1. Draw the mountains first, then paint the snowy areas with masking fluid on a fine brush.

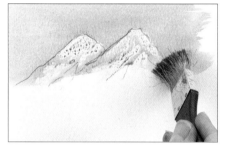

2. When the fluid is completely dry, paint the sky using the golden leaf brush. Paint over the mountain tops.

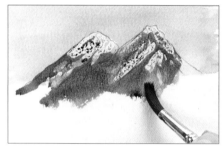

3. Mix a dark grey from ultramarine and burnt umber and use the large detail brush to paint in the mountains.

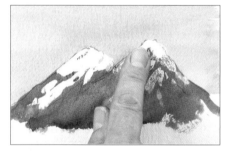

4. When the paint is dry, rub off the masking fluid with your fingers to reveal the white paper underneath.

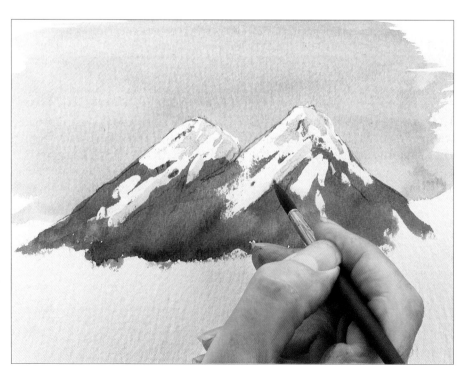

5. Using cobalt blue and the medium detail brush, paint shadows in the snow.

Tip

If your brush does become clogged with masking fluid, you can remove it using lighter fluid, but do not breathe in the fumes.

Ripples on water

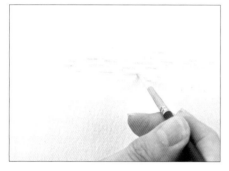

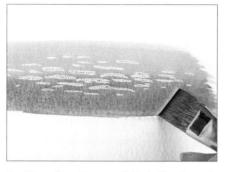

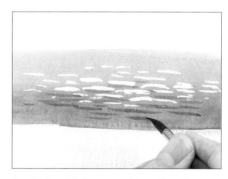

1. Paint the ripples using masking fluid and a fine brush.

2. Use the 19mm (¾in) flat brush with horizontal strokes to paint the water.

3. Rub off the masking fluid when the paint is dry. Add darker ripples in the foreground using the medium detail brush and a strong mix of ultramarine.

Waterfall

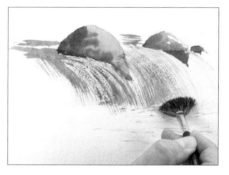

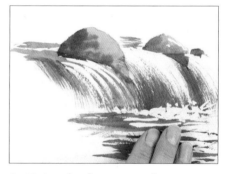

1. Draw in the rocks and the water. Paint the masking fluid on, dragging the brush down the fall of water. In the rock pool, add dots, splashes and ripples.

2. Paint in the rocks using raw sienna, burnt umber and ultramarine. Paint a darker mix of ultramarine and burnt umber in to the shadowed part of the rock. Allow it to dry, then take the fan gogh and drag a blue mix of ultramarine and burnt umber down the waterfall.

3. Paint the foreground water with the same colour. When it is dry, remove the masking fluid with your fingers.

4. Add ripples in a lighter blue with the medium detail brush.

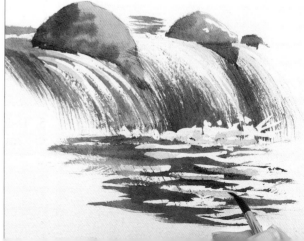

Using a paper mask

This is a very simple way of achieving great results. You take a piece of coated paper from something like a brochure or leaflet (photocopier paper is too absorbent), and use the edge to mask an area where you want a straight line, for example the side of a building, a wall or the water's edge. You can cut the paper to any shape required.

Water's edge with trees

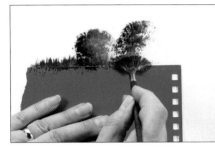

1. Place a paper mask where you want the water's edge to be and use the fan stippler and various greens to suggest grasses and trees.

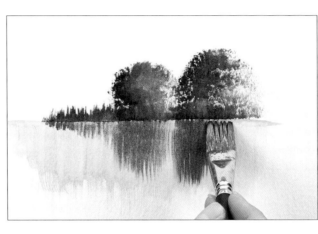

2. Remove the mask and use the 19mm (¾in) flat brush to paint water with downward strokes. Pick up some green and drag it down in to the wet blue.

Stone walls

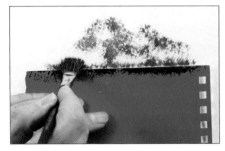

1. Mask the bottom of the wall area and use the foliage brush and ultramarine and burnt umber to stipple texture above it.

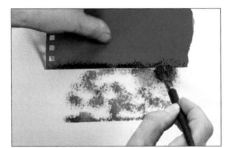

2. Mask the top of the wall and continue stippling.

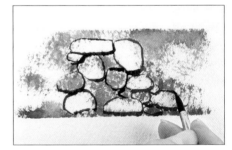

3. Take a darker mix of the same colours and the medium detail brush. Pick out dark and light areas in the stippling and paint round them to create stones.

Hillside barn

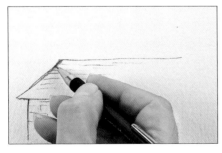

1. Draw the barn first.

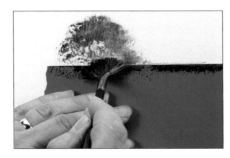

2. Mask the top of the roof and use the fan stippler to create foliage behind the barn.

3. Move the paper to mask the angle of the roof and continue stippling.

4. Mask the wall of the barn and stipple behind it.

The finished shape of the barn.

Village Stream

390 x 420mm (15³/₈ x 16¹/₂in)

The patchwork fields with their hedgerows and trees in this green and pleasant valley were created using the paper mask technique. The foliage brush was used to create the texture of the stonework on the cottages, and the detail was added using the half-rigger.

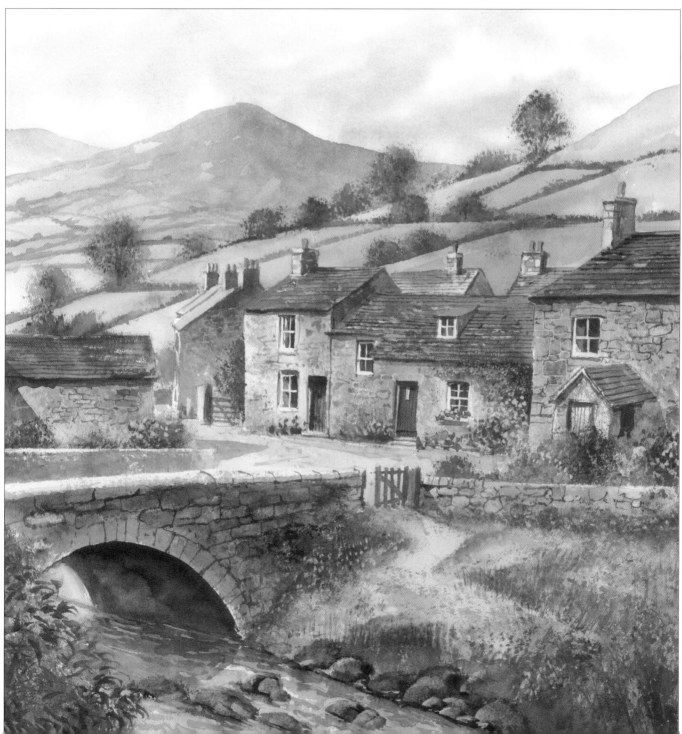

Painting skies

When painting landscapes, you are bound to have to paint skies. If you learn to paint a basic sky, you can apply the techniques to most landscapes.

Summer sky with lifting out

1. Wash the sky area first with clean water. Use the golden leaf brush and ultramarine to apply a blue wash. As the brush travels down the paper, the water on the surface dilutes the colour in the brush, making it progressively lighter towards the horizon.

2. Paint in clouds wet into wet using a dark mix of ultramarine and burnt umber.

3. Dab the tops of the clouds with kitchen paper or tissue to lift out colour.

Winter sky

1. Wet the sky area with clean water, then using the golden leaf brush, apply a weak wash of raw sienna to the bottom half.

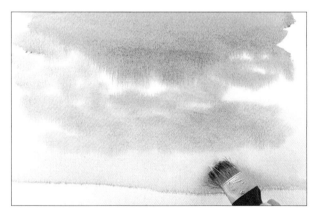

2. Apply a second wash of ultramarine and burnt umber from the top, wet in wet. Leave some white for clouds.

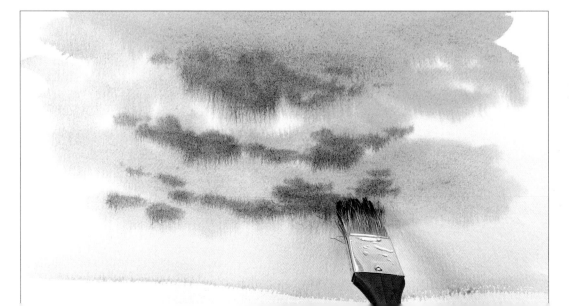

3. Using a stronger mix of the same colours, dab with the bristle ends of the golden leaf brush to suggest dark clouds.

Stormy sky

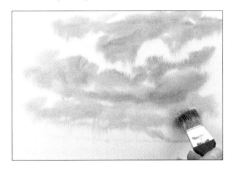

1. Wet the sky. Use the golden leaf brush and ultramarine with a touch of burnt umber to paint a cloud formation.

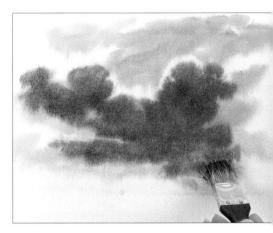

2. Rough in darker clouds wet in wet using a stronger mix of the same colours.

Sunset

1. Wet the paper then, using the golden leaf brush, paint a wash of cadmium yellow in the centre and crimson at the top and bottom. Fade the crimson bands into the yellow wet in wet.

2. Paint a wash of cobalt blue from the top, fading down into the wet crimson. Using crimson will stop the blue and yellow turning to green.

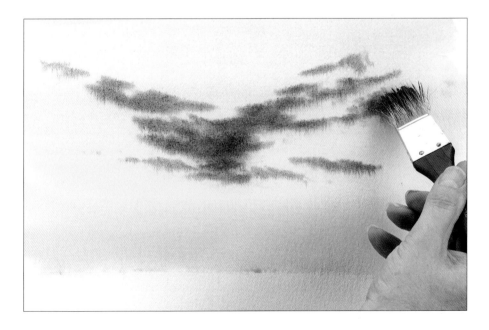

3. Use shadow and the golden leaf brush to paint a cloud formation wet in wet, drifting into the centre of the sky.

Painting mountains

Mountains can be painted in many different moods: distant, misty mountains; harsh granite edifices and imposing, majestic peaks. Using a variety of simple techniques, you can easily create the painting of your choice.

Snow-covered mountains

1. Draw the mountain and paint masking fluid on to the snowy areas.

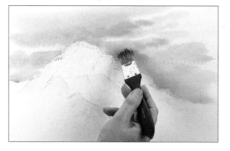

2. Wet the sky area and use the golden leaf brush and ultramarine to suggest cloud shapes. Add darker shapes wet in wet with a stronger mix.

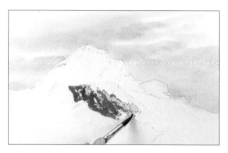

3. Mix a cool bluey-brown from ultramarine and burnt umber and using the large detail brush, drag it over the shaded area using the dry brush technique.

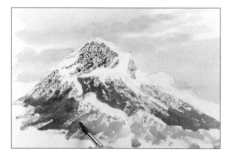

4. Make a warmer mix of burnt umber with a touch of ultramarine and drag paint over the sunlit side of the mountain.

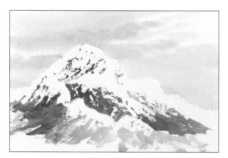

5. When the paint is dry, remove the masking fluid.

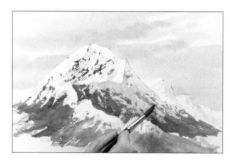

6. Use a cool blue such as cobalt blue and the large detail brush to paint the shaded areas of snow. Allow to dry.

7. Use the medium detail brush and a bluey-grey mix to paint in the finer details of the rock formation.

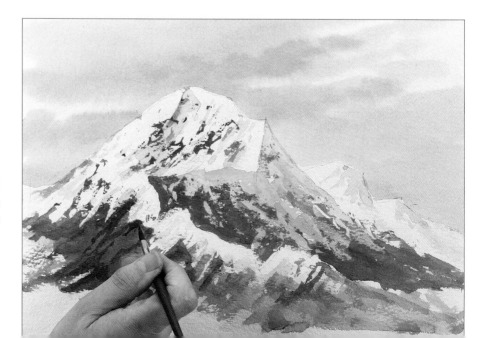

Distant mountains

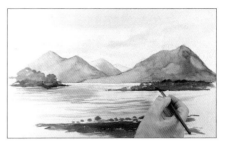

1. Wet the sky area with clean water. Using the golden leaf brush, paint the sky behind the hills with raw sienna. Then paint ultramarine from the top down into the wet raw sienna. Allow the painting to dry.

2. Using the large detail brush with pale ultramarine, paint the distant mountain. Let each mountain dry before beginning the next. Paint the mountain in front of that using shadow. Then paint the mountains on the left with shadow and raw sienna. Use a stronger mix to paint the mountain on the right.

3. Take the 19mm (¾in) flat brush and ultramarine with a touch of shadow and paint the water. In the foreground use shadow with burnt umber and the medium detail brush with the dry brush technique to paint pebbles on the shoreline. On the far shore paint dark rocks, and on the right a dark headland.

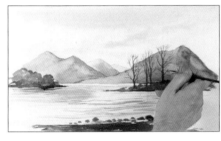

4. Use the half-rigger and the same dark mix to paint in trees on the headland.

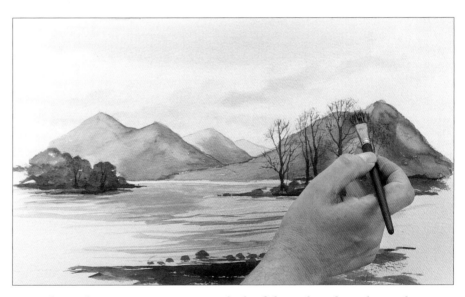

5. Pick up the same mix again with the foliage brush and stipple into the trees.

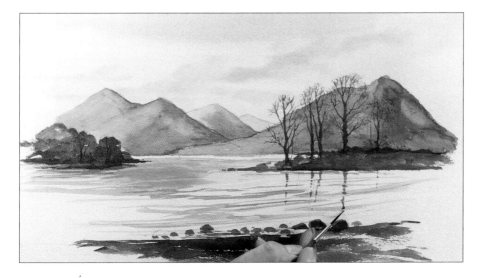

6. Use the half-rigger to paint reflections beneath the trees, using broken lines to suggest ripples in the water.

Misty mountains

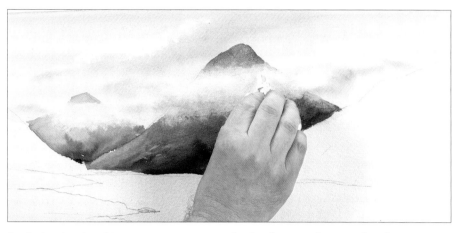

1. Wet the sky area and the mountains. Take the golden leaf brush and paint an ultramarine wash. Suggest clouds with ultramarine and burnt umber and lift out the tops with kitchen paper.

2. Paint in the distant mountain with shadow and a touch of ultramarine, using the large detail brush. Add raw sienna wet in wet. Paint the larger mountain with raw sienna. While this is still wet, lift out the clouds again using kitchen paper or tissue.

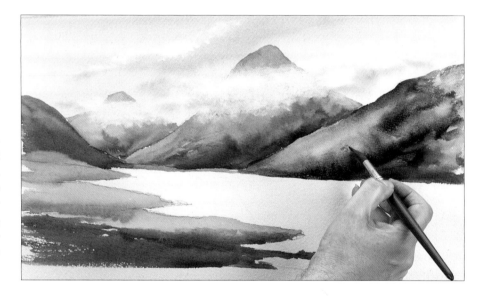

3. Paint the right-hand mountain with shadow. Add raw sienna wet in wet. Paint raw sienna and sunlit green towards the foreground, then burnt umber and country olive. Paint the right-hand bank with shadow and country olive, and add raw sienna wet in wet.

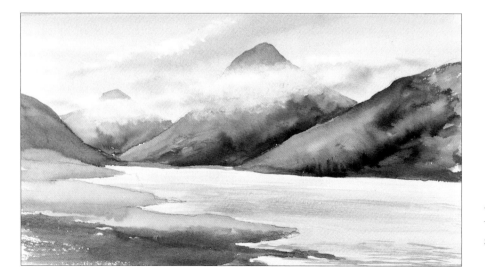

4. Mix ultramarine with a touch of burnt umber and sweep in the water with the 19mm (¾in) flat brush.

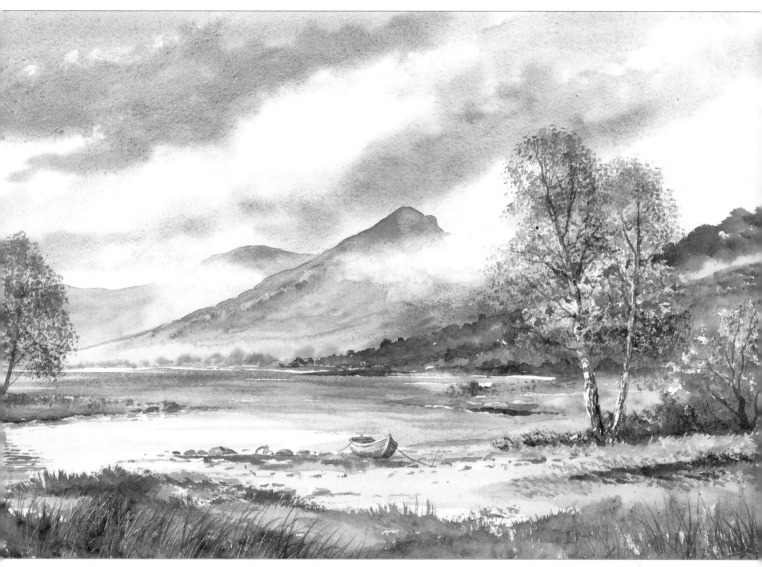

Misty Glen
520 x 350mm (20½ x 13¾in)
*The clouds in this picture drift across the painting and obscure
parts of the mountains, creating a distant effect and a peaceful and
atmospheric scene.*

Painting valleys

Valleys can evoke as many different moods as mountains, from peaceful and tranquil to wild and rugged.

Rolling hills

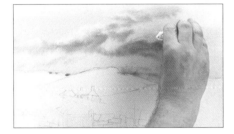

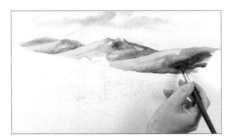

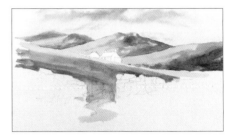

1. Wet the sky area. Apply an ultramarine wash, add ultramarine and burnt umber clouds and lift out colour with kitchen paper.

2. Paint the hill on the far left with shadow and the middle two with raw sienna and shadow. Use raw sienna with a touch of warm burnt umber for the right-hand hill. Add a touch of midnight green and country olive on the far right.

3. Using the large detail brush and raw sienna with a touch of sunlit green, paint the middle distance. Add shadow for the road and raw sienna for the footpath.

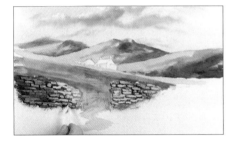

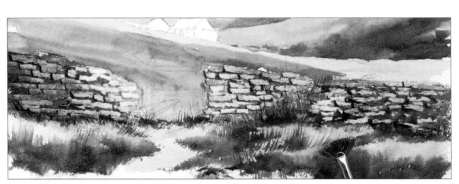

4. Use the foliage brush to stipple raw sienna on the stone wall, then sunlit green, then burnt umber and ultramarine on top. Use the scraper end of a px brush to scrape out stone shapes.

5. Paint foreground grasses using the fan gogh and country olive with burnt umber. Stipple raw sienna, then ultramarine and burnt umber on to the right-hand wall and scrape out stones. Paint darks in the foreground with burnt umber and country olive.

6. Paint the stile with the large detail brush and burnt umber with country olive. Allow it to dry, then use the small detail brush with cobalt blue and burnt umber and paint the sunlit roof. Use a warmer mix for the other roofs and architectural details, and to shadow the stile.

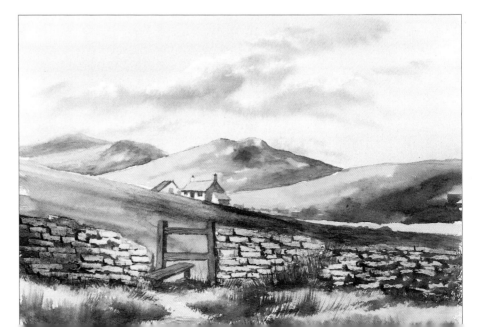

Craggy valley

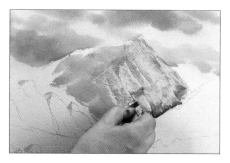

1. Wet the sky area with clean water, then apply a wash of raw sienna with the golden leaf brush. Drop in ultramarine and burnt umber cloud shapes wet in wet. Allow to dry.

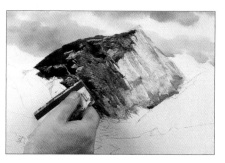

2. Paint the mountains with the same brush and a mix of cobalt blue and burnt umber. Drop in raw sienna wet in wet. Firmly scrape out the shapes in the rock using a plastic card.

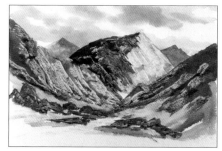

3. Use a darker mix of the same colours on the shadowed left-hand side and scrape out again with the plastic card.

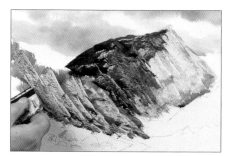

4. Paint the rocks on the left with a warmer mix including raw sienna. Scrape out the rock shapes using sharp diagonal strokes.

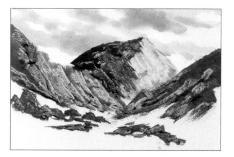

5. Paint the rocks on the far left, far right and in the foreground using the 19mm (¾in) flat brush and a mix of ultramarine and burnt umber. Scrape out all these areas while they are wet.

6. Use the large detail brush with raw sienna and sunlit green to fill in the spaces between rocks in the foreground. Paint the distant hills a bluey grey mixed from ultramarine and burnt umber.

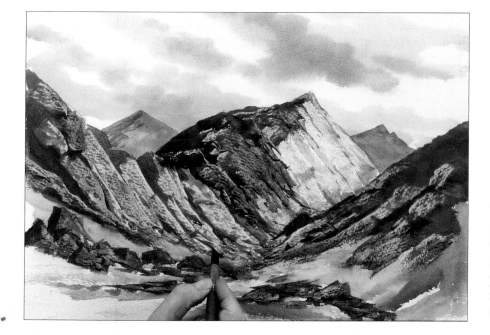

7. Allow the painting to dry before adding detail. Make an almost black mix from ultramarine and burnt umber and use the large detail brush to paint diagonals on the middle mountain, fault lines in the rocks and foreground details.

Green valley

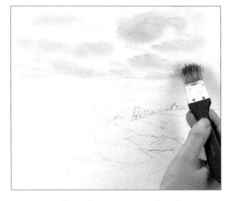

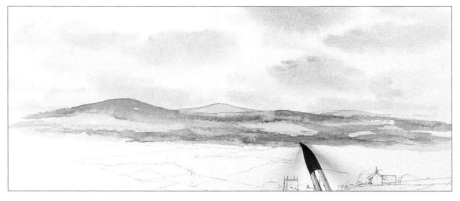

1. Wet the sky area with clean water then drop in ultramarine with the golden leaf brush for cloud shapes. Add ultramarine and burnt umber wet in wet for darker clouds.

2. Paint the most distant hills with the large detail brush and cobalt blue with a touch of midnight green. Use a lighter mix with raw sienna added as you move further forwards. Paint in the shapes of the rows of hills.

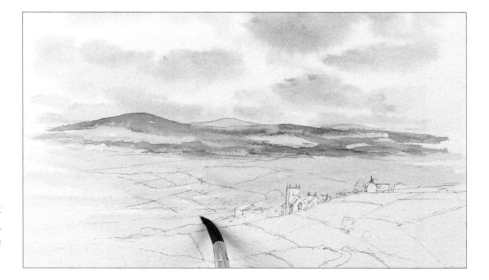

3. Make a lighter mix with more raw sienna and paint the middle distance up to the village.

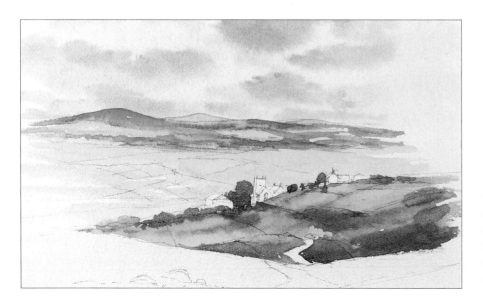

4. Mix a warm green from country olive and a little raw sienna to paint the area coming towards the foreground. Leave a space for the path. Paint the trees around the village.

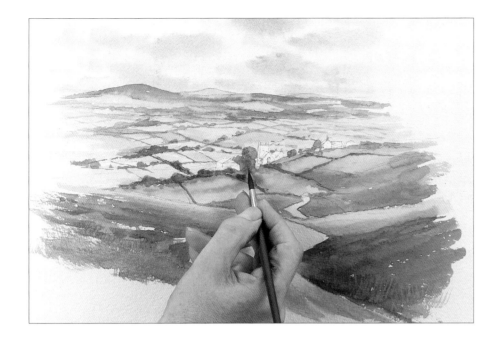

5. Mix a slightly stronger green from raw sienna with a little country olive for the foreground. Add country olive with a touch of burnt umber for the left-hand side of the foreground. Use the medium detail brush and raw sienna with a little burnt umber for the track. Paint the middle distance hedgerows with ultramarine with a touch of country olive. Dot a few trees along the hedge line. Strengthen the green in some of the middle distance fields. Vary the shades of the fields, painting some in burnt sienna. Allow the painting to dry.

6. Add detail to the village, painting wet on dry. Use the small detail brush and raw sienna to give the impression of warm stonework. Mix burnt umber and ultramarine, not too dark, for architectural details. Add lines across some of the fields in the middle distance.

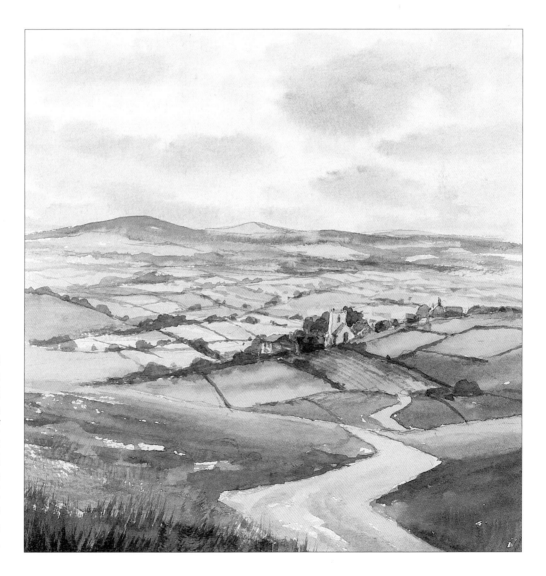

Painting water

There always seems to be water at the bottom of a mountain, whether it is in a lake, a river or a stream, so when painting mountains, the chances are you will need to paint some water. Here are a few simple techniques to help you master this seemingly impossible subject.

Still water

Wet the paper with clean water and a 19mm (¾in) flat brush. Make a strong mix of ultramarine. Still water is darker in the foreground so apply the wash from the bottom upwards. Zigzag up the page, and the wash will become progressively more diluted by the water on the paper.

Rippled water

1. To add ripples, squeeze water out of the brush and use it to lift out colour in irregular horizontal lines. Also lift out any beading of paint at the bottom.

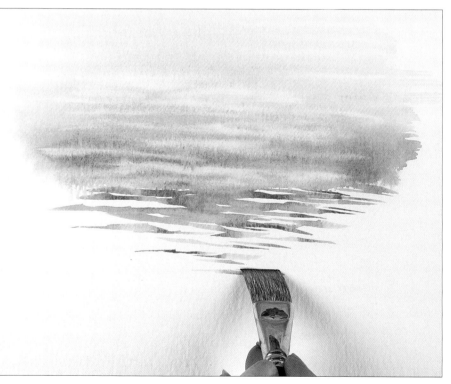

2. Painting on to the dry paper in the foreground, extend the ripples forwards with horizontal brush strokes, leaving white spaces between them.

Reflections in still water

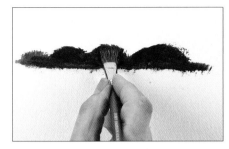

1. Using the foliage brush, paint layers of dry paint: first raw sienna, then burnt umber and then a mix of ultramarine and burnt umber.

2. Scrape out rock shapes using a plastic card. Start with the rocks furthest away. When scraping out, the edge of the card should end up horizontal at the base of the rock.

3. Using the wizard brush, paint a blue wash almost up to the rocks.

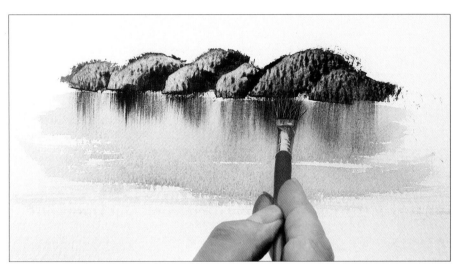

4. Working wet in wet, pick up rock colours with the wizard brush and drag them down from the rocks into the water wash to create reflections.

Moving water

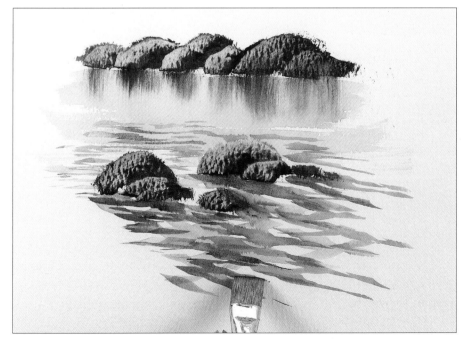

Add rocks in the foreground and scrape them out as before. Use the 19mm (¾in) flat brush and the rock mix to add ripples and to suggest water moving round the rocks. Add a bluer colour and paint more ripples, creating a crisscross pattern. Add greens.

35

Mountain Lake

This painting shows Ashness Bridge, overlooking Derwent Water in the Lake District. Although this is a painting of a mountain lake, the lake itself is a very small part of the scene. The bridge appears to be the dominant feature, but the eye is inevitably drawn to the lake at the foot of the mountains. The stone bridge is painted in the traditional way, painting texture on to the paper rather than using the scraping out technique. The rocks are done using the credit card technique.

1. Draw the scene. Dip the ruling pen in masking fluid and flick up grasses in the foreground.

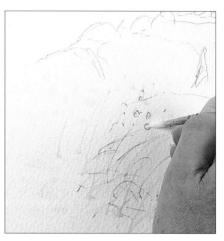

2. Change to a brush to paint on blobs of masking fluid for the flower heads. Remember to wet the brush and coat it in soap first to protect it.

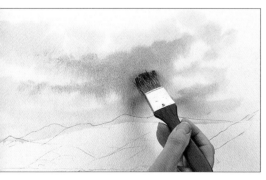

3. Use the golden leaf brush to paint clear water on the sky area, then drop in a touch of raw sienna around the horizon and the top of the hills. Brush in clouds using ultramarine, then paint ultramarine and burnt umber wet in wet to shadow them.

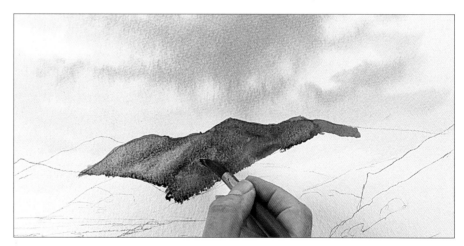

4. Paint the distant hills using the large detail brush with ultramarine, burnt umber and a touch of shadow. While the paint is wet, drop in raw sienna on the sunlit side, wet in wet. The colour will blend in to the darker paint.

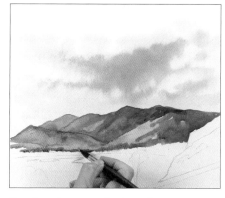

5. Continue painting the mountains, adding raw sienna wet in wet. Add sunlit green towards the middle ground. On the right add a dark bluey-grey mixed from ultramarine and burnt umber. Stop short of the trees.

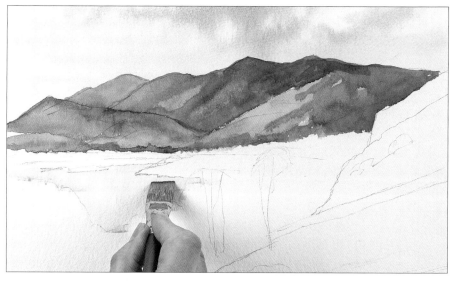

6. Use the 19mm (¾in) flat brush to paint in the lake. Pick up a little ultramarine and drag it down, then leave it to dry.

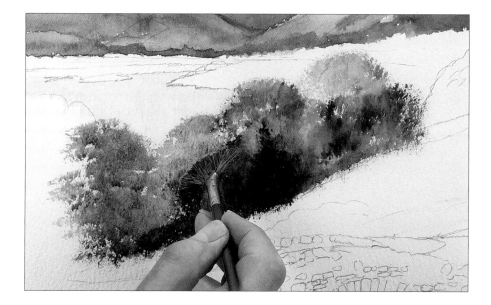

7. Use the fan stippler to paint sunlit green and country olive for the trees and hedge, then midnight green and burnt umber for the darker parts. Stipple on raw sienna wet in wet.

8. Scrape out the trunks of the silver birch trees using the scraper end of a px brush.

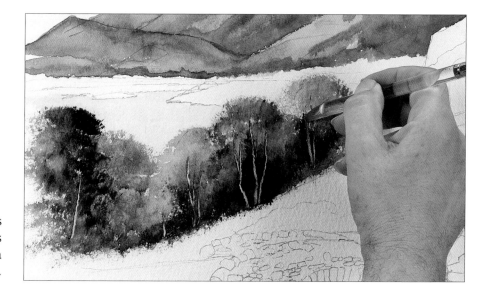

37

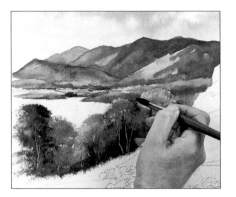 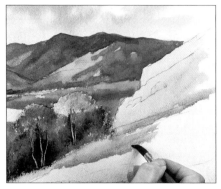 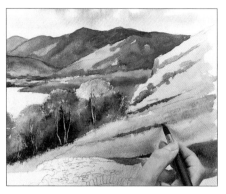

9. Finish the headland behind the trees using the large detail brush and a thin mix of sunlit green and raw sienna. Paint country olive with a touch of ultramarine in the distance to create contrast with the trees.

10. Paint the slope on the right with raw sienna, then add a touch of burnt sienna to give the impression of bracken.

11. Add a touch of country olive towards the foreground, and add burnt umber to the green, wet in wet, down towards the bridge. As the paint dries, add details using burnt umber and country olive.

12. Wash over the stonework of the bridge using the foliage brush and raw sienna. Allow it to dry.

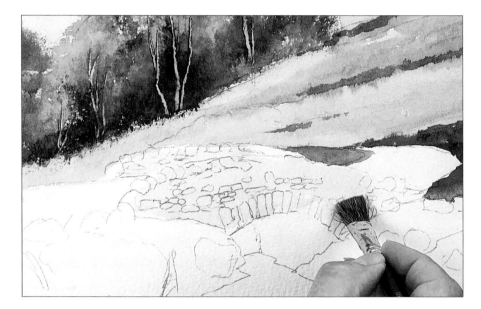

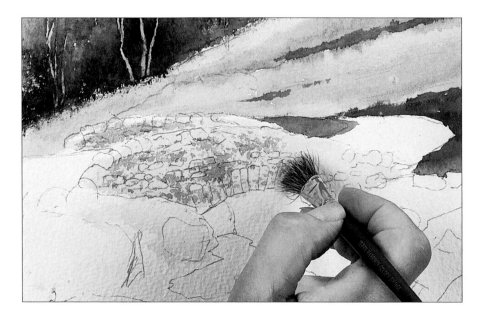

13. Stipple on ultramarine and burnt umber wet on dry. Allow the paint to dry.

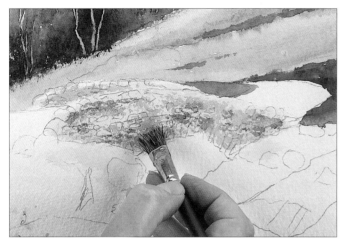

14. Still using the foliage brush, stipple on a hint of country olive to add some moss. Allow to dry.

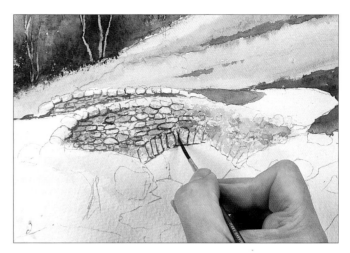

15. Use the half-rigger brush and ultramarine with burnt umber to paint the details of the stonework. Outline areas of dark and light that appear in the stippled area.

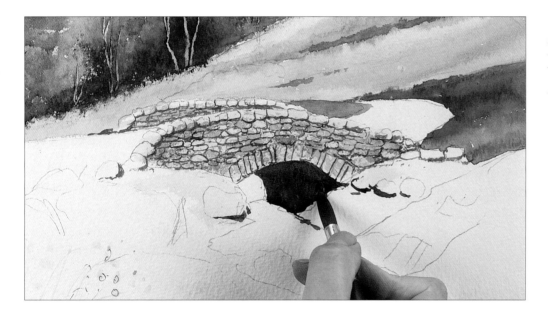

16. Paint in the dark area under the bridge using the large detail brush and ultramarine and burnt umber.

17. Paint over the rocky area in front of the bridge using the fan stippler and a very thick mix of raw sienna and ultramarine. Go over this with a darker mix of the same colours while the paint is still wet.

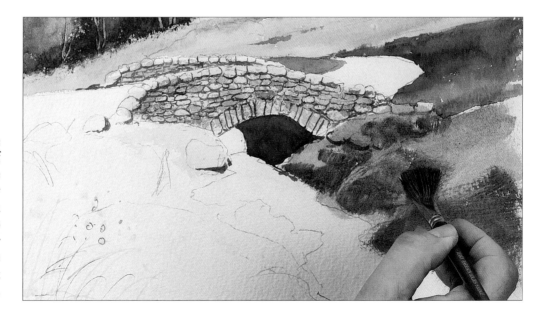

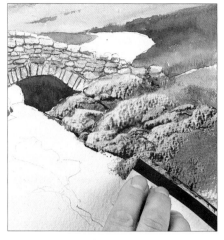

18. While the paint is wct, use a plastic card to scrape out rock shapes.

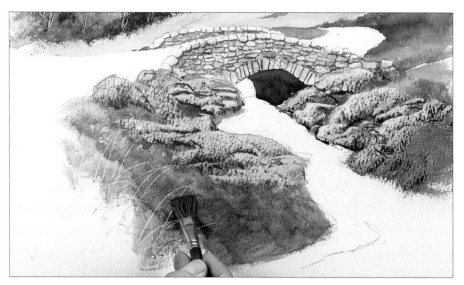

19. Paint over the rocky area on the left in the same way and scrape out rocks. Paint over the masked out grasses.

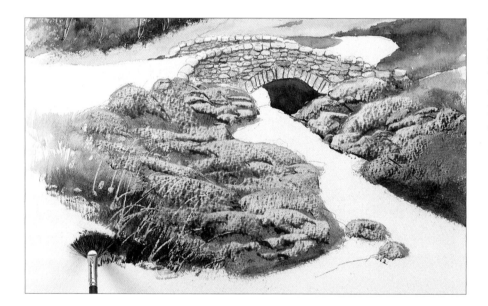

20. Use the fan gogh brush to paint the grassy area with light colours first, then darker. Start with sunlit green, then country olive, then midnight green, flicking up the brush to produce a grassy texture.

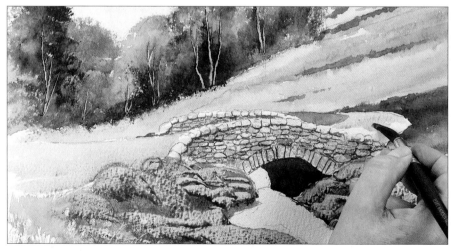

21. Wash colour into the road using the large detail brush and raw sienna with ultramarine.

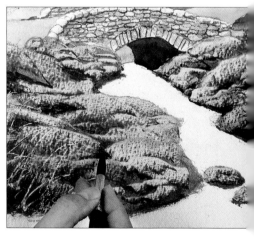

22. Add dark details among the rocks using ultramarine and burnt umber.

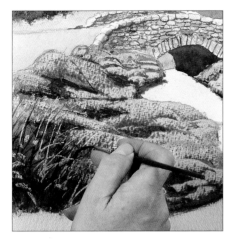

23. Use the half-rigger to add detail and grasses on top of the dried background.

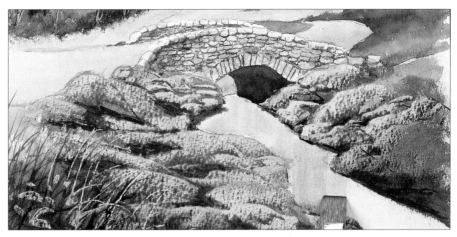

24. Make a weak wash of ultramarine and use the 19mm (¾in) flat brush to drag it down to paint the stream.

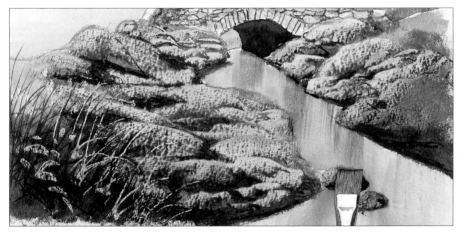

25. While the paint is wet, pick up ultramarine and burnt umber and drag it down to create reflections.

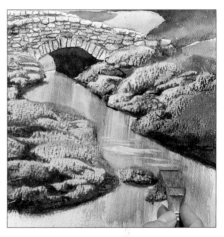

26. Clean and dry the brush and use it to lift out ripples in the stream.

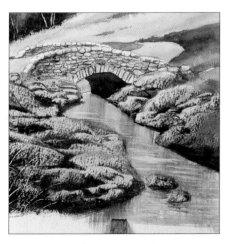

27. Add reflections to the stones and left bank using ultramarine and burnt umber.

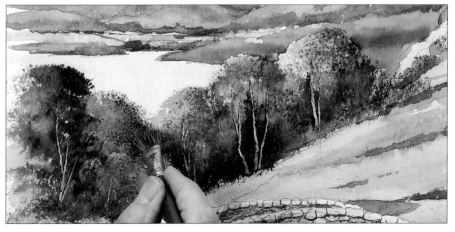

28. Use the foliage brush and fairly dry country olive to stipple detail over the trees.

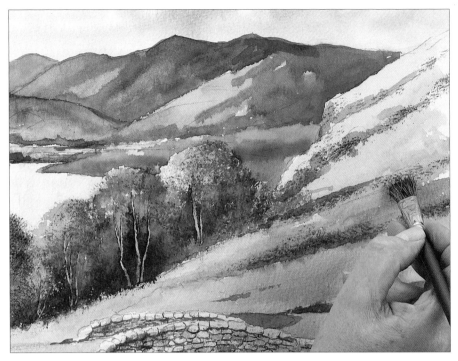

29. Stipple the bracken on the right-hand slope using the foliage brush and burnt sienna.

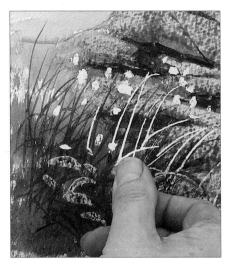

30. Remove the masking fluid from the grasses and flower heads by rubbing with your fingers.

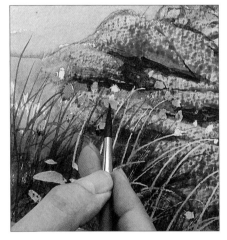

31. Use the medium detail brush to paint a sunlit green wash over the white grasses. Then paint alizarin crimson on to the flower heads.

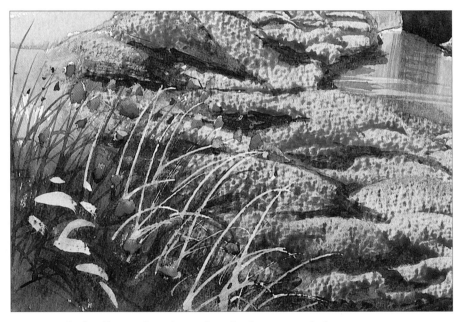

32. Touch the flower heads with a darker mix of alizarin crimson, wet in wet.

Opposite
The finished painting
360 x 510mm (14¼ x 20in)
After standing back from the painting, I added darker reflections and ripples in the water, wet on dry, and I also painted darker green branches in some of the trees.

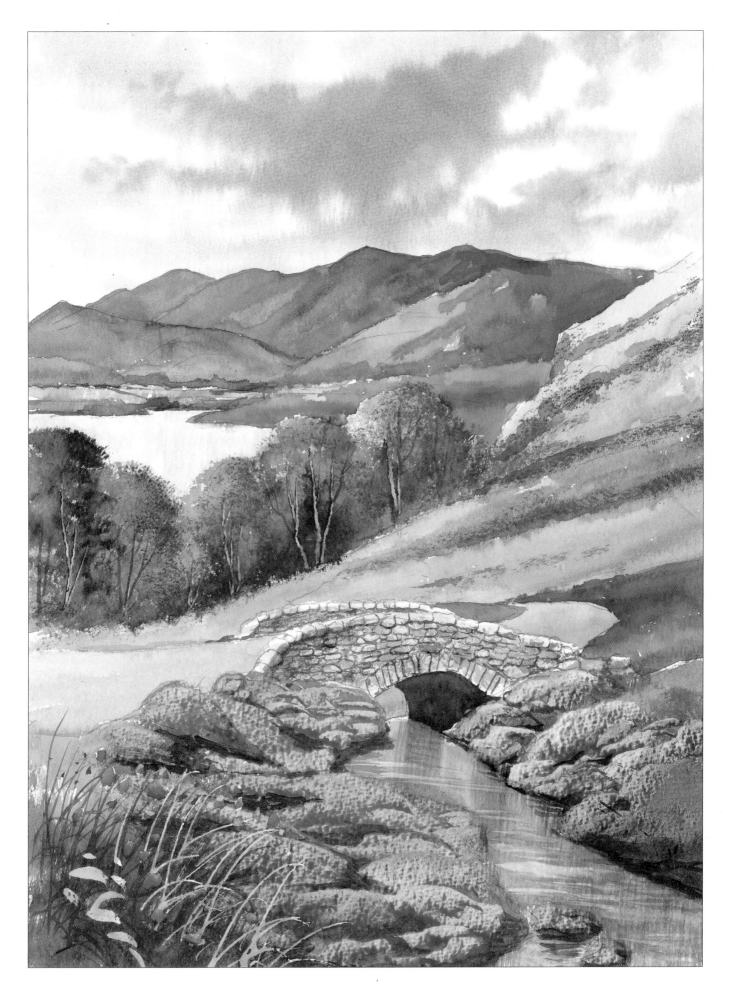

Valley View

This painting uses masking fluid, paper masking, scraping out and wet into wet techniques. The dominant feature is the wall that leads you into the valley, through the hamlet and on into the valleys and mountains beyond.

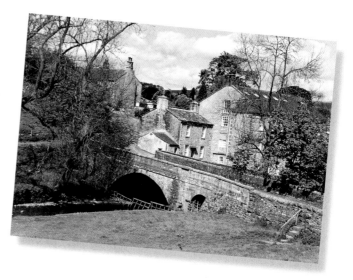

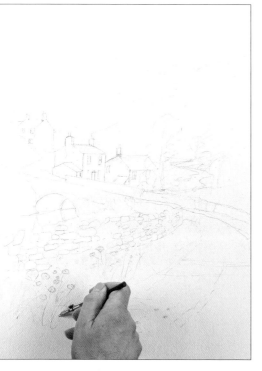

1. Use a brush to apply masking fluid to the flower heads. Then dip a ruling pen in masking fluid and mask off the chimney stacks and the foreground grasses.

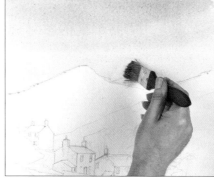

2. Use a golden leaf brush to wash clean water over the sky area, then apply an ultramarine wash from the top downwards.

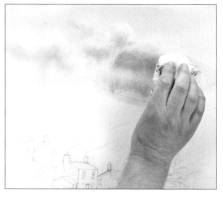

3. Paint ultramarine and burnt umber clouds using the golden leaf brush, then lift out the sunlit tops of the clouds using kitchen paper. Allow to dry.

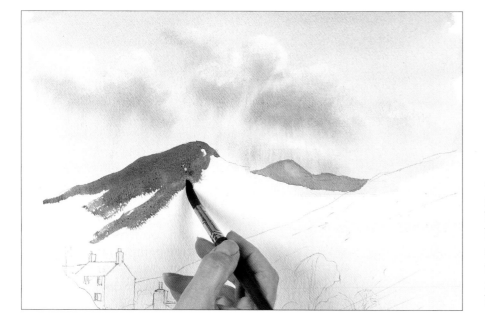

4. Paint the most distant mountain using the large detail brush and ultramarine with burnt umber. Add a touch of raw sienna to the sunlit side. Paint the dark side of the second mountain with ultramarine, burnt umber and shadow.

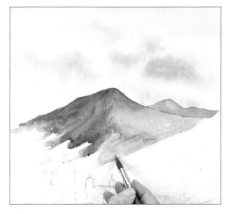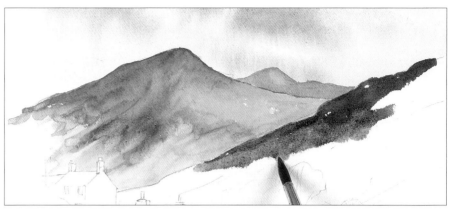

5. Add raw sienna wet in wet on the sunlit side of the mountain. It will blend into the darker paint.

6. Paint the right-hand hill using ultramarine and burnt umber with a touch of shadow. Then add raw sienna and burnt sienna.

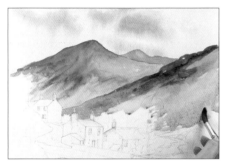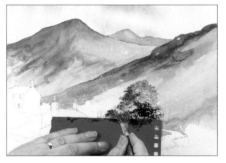

7. Continue to paint with raw sienna further down the paper, then add a touch of sunlit green as you go down into the valley. Allow to dry.

8. Mask off the roofline of a building with a paper mask and use a foliage brush and sunlit green to stipple in the trees.

9. Continue stippling the tree area in this way, varying the tone of the greens.

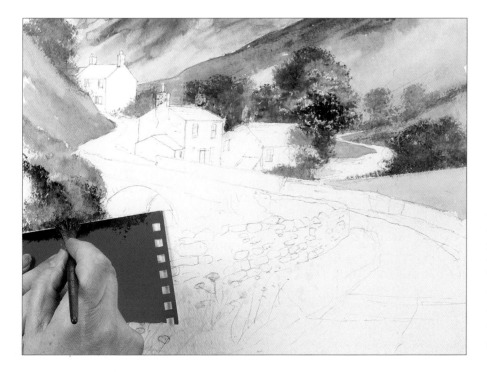

10. Take the large detail brush and wash in raw sienna and sunlit green for the right-hand field and the slope on the left of the painting. Then use the foliage brush and country olive to stipple the foliage going down towards the left-hand river bank. Mask off the river with a paper mask and continue stippling.

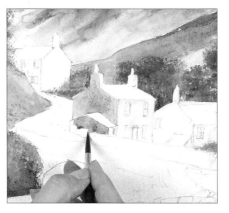

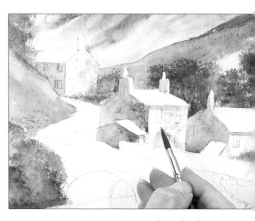

11. Remove the masking fluid from the chimney pots. Use the medium detail brush and a very pale wash of raw sienna and ultramarine to paint the sunlit fronts of the buildings.

12. Paint ultramarine and burnt sienna on the darker sides of the buildings.

13. Continue painting the darker details such as the shadows under the eaves. Use the same darker shade and dry brush work to add texture to the dried paint on the sunlit sides.

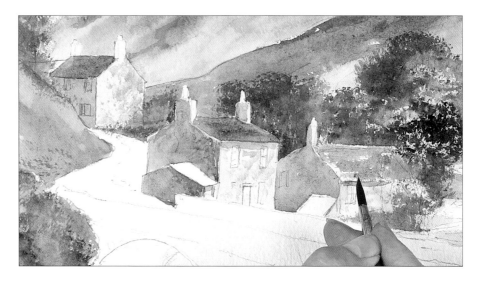

14. Use the medium detail brush to paint the slate roofs with ultramarine and burnt umber.

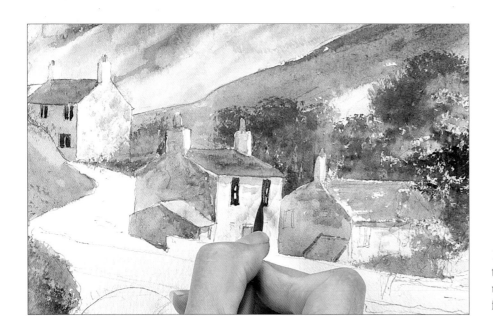

15. Paint the chimney pots and the doors with burnt sienna, then use ultramarine and burnt umber for the window darks.

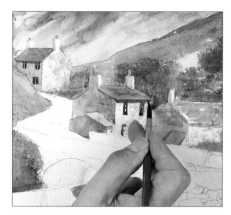

16. Use the same dark colour for the shadows under the eaves.

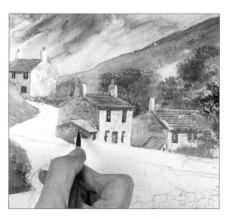

17. Continue painting the architectural details such as the slates on the roofs.

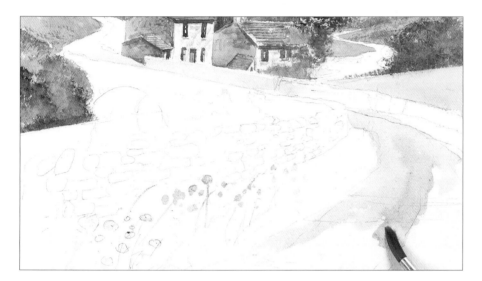

18. Use the large detail brush and a wash of raw sienna and cobalt blue to paint the road.

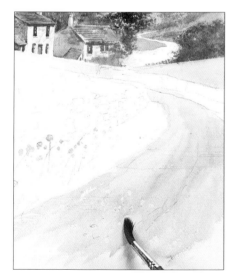

19. Continue painting the road, adding more cobalt blue wet in wet towards the foreground.

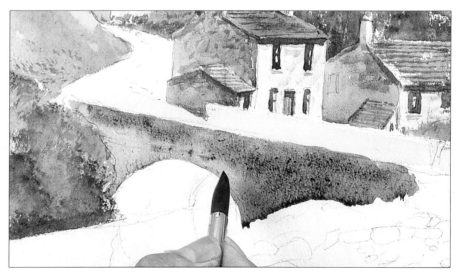

20. Paint the bridge with ultramarine and burnt sienna and the large detail brush. While the paint is wet, drop in burnt sienna.

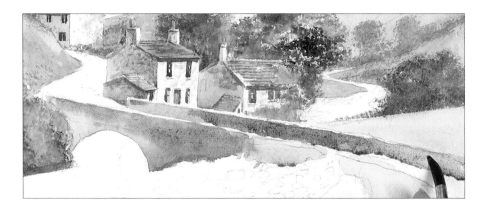

21. Paint the further parapet of the bridge using a greyer mix of ultramarine and burnt sienna.

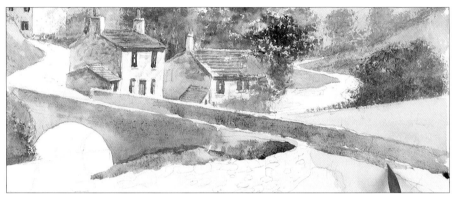

22. Still using the large detail brush, paint greenery along the bank and wall with sunlit green and a little country olive.

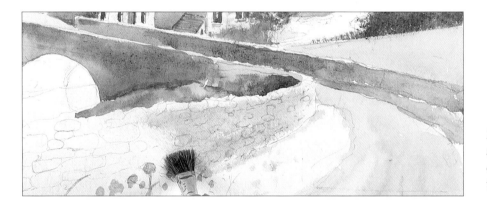

23. Use the foliage brush to stipple the stone wall with a light colour first: raw sienna with a touch of cobalt blue.

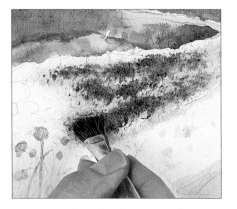

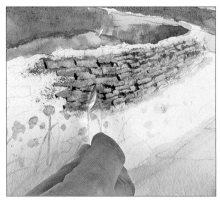

24. Stipple a darker mix of burnt umber and ultramarine over the top.

25. Scrape out stone shapes with the scraper end of a px brush.

26. On the left-hand side of the wall, stipple on a bright mix of raw sienna and sunlit green, using the foliage brush.

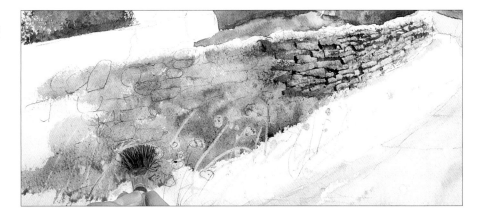

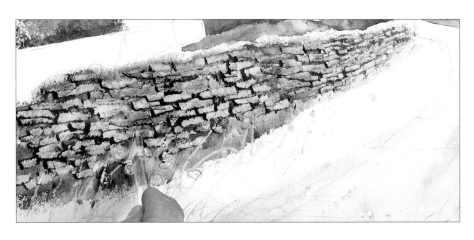

27. Stipple burnt umber and ultramarine over the bright mix and scrape out stone shapes with the end of a px brush.

28. Use the fan gogh brush and sunlit green with raw sienna to stipple over the masking fluid in the area of the grass verge. Stipple midnight green over the top.

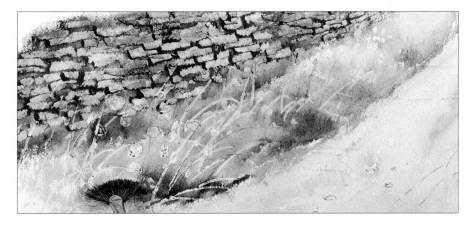

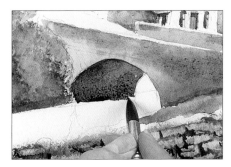

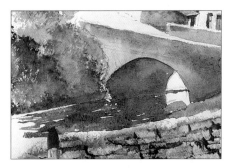

29. Paint the dark arch of the bridge with ultramarine and burnt umber.

30. Paint the water with a touch of ultramarine, then add reflections of the foliage greens. Leave white spaces for ripples.

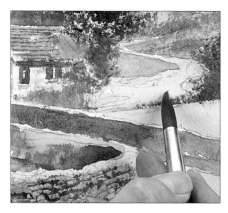

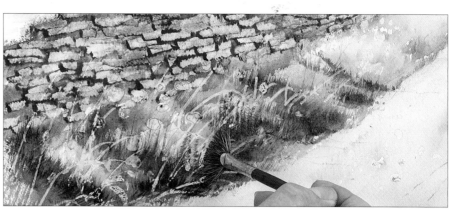

31. Paint the more distant water with the large detail brush and a weak wash of cobalt blue.

32. Use the fan gogh brush and midnight green to flick up grasses on the verge.

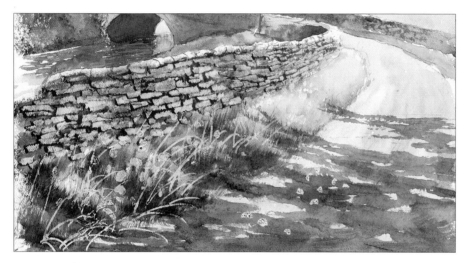

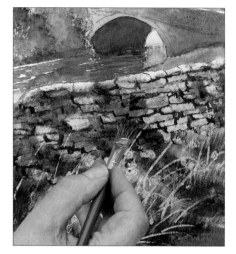

33. Use the wizard brush and shadow with a touch of cobalt blue to paint the foreground shadows, going across the road, over the masking fluid and up into the bank. This will accentuate the light area in the centre of the painting, making it the focal point.

34. Continue the shadow up the wall, glazing a thin mix over the dried paint.

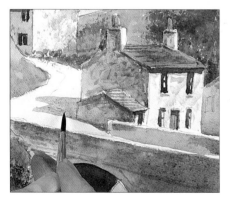

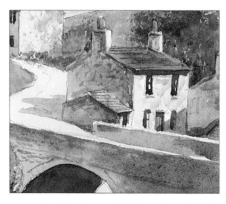

35. Use the small detail brush to add the shadow on the road from the central building.

36. Shade the right-hand side of the central building where shadow from the building on the right falls on it.

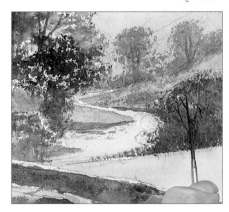

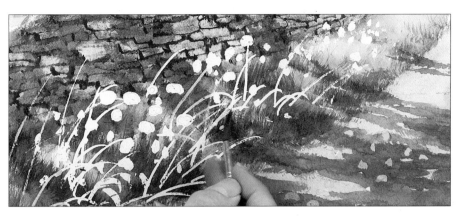

37. Add detail to the central area around the water. Use the half-rigger brush and midnight green to add branches to the trees.

38. Remove the masking fluid from the grass verge area. Use the small detail brush to paint the grasses in sunlit green and in country olive for the shaded areas.

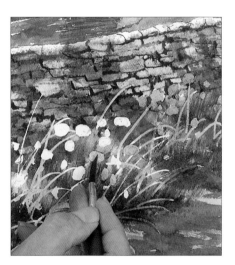

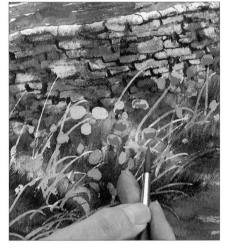

39. Drop a pale wash of cadmium red on to the flower heads.

40. Drop a deeper red mix into the wet paint.

41. To finish the poppies, drop shadow into the centres of some but not all of the flower heads.

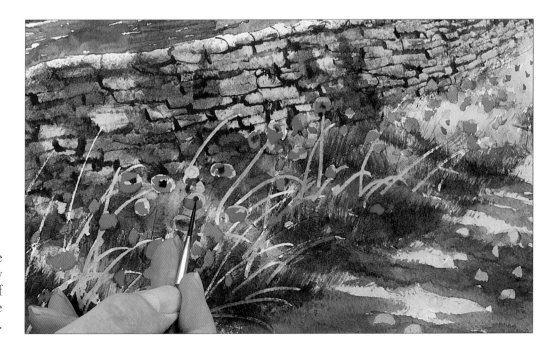

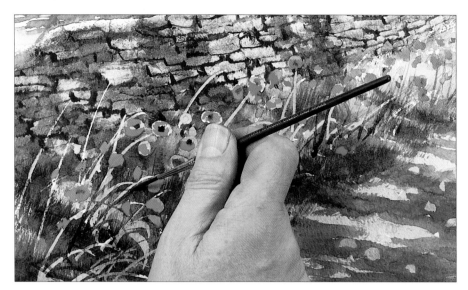

42. Use a half-rigger and midnight green to add darker grasses to the verge area.

43. Paint shadows under the stones using the half-rigger brush and ultramarine mixed with burnt umber.

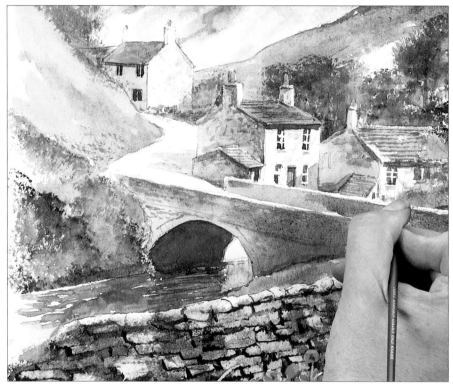

44. Use white gouache to paint highlights such as the ripples in the water and the bars in the windows.

Opposite
The finished painting
370 x 500mm (14½ x 19¾in)
The dark shadow in the foreground is an important feature of this composition. It balances the dark of the mountains at the top and focuses attention in the centre of the painting.

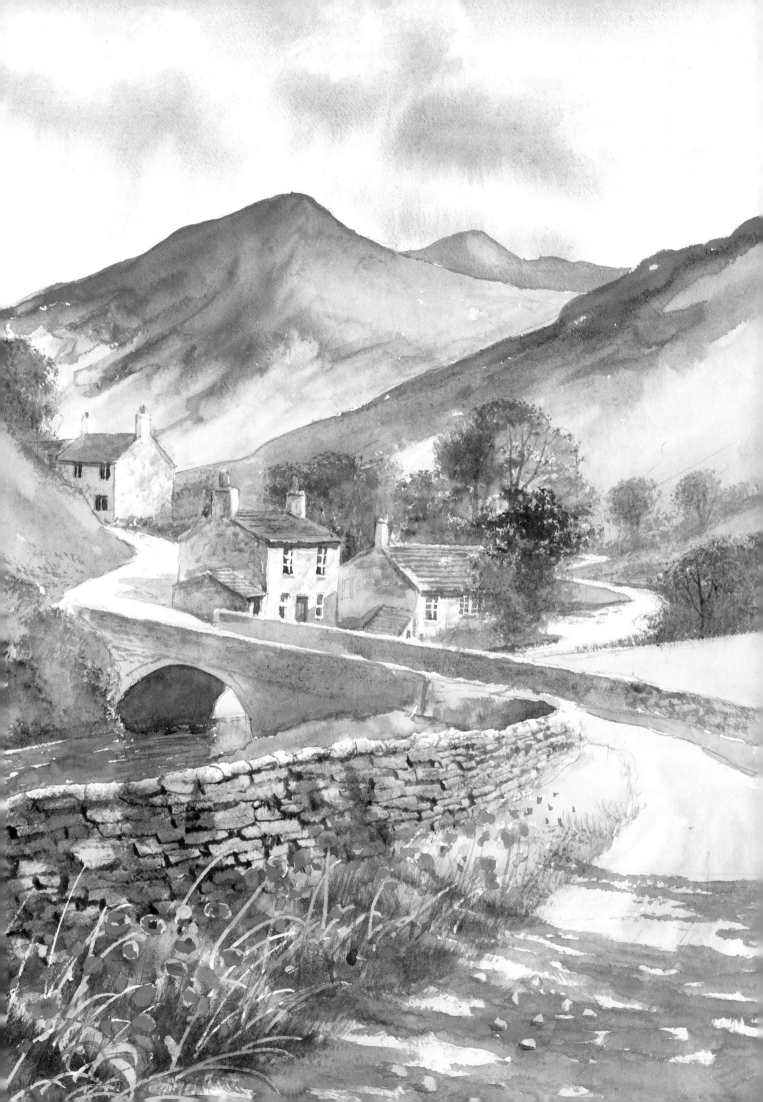

Mill Stream

There is nothing more peaceful than being beside running water. In this painting the waterfall and the overhanging tree frame the mill buildings in the background.

When choosing your subject, beware of trespassing on private property, as it turned out I was when photographing this scene. If caught, do not hesitate to apologise and beat a hasty retreat.

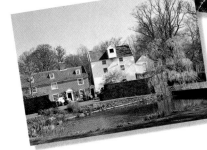

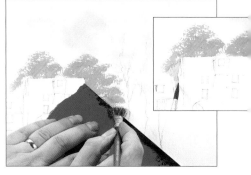

1. Draw the scene. Use masking fluid with a brush to mask the fence uprights, the ripples in the waterfall, the flowers on the opposite bank and the leaves in the foreground. Then use the ruling pen with masking fluid to mask the foreground grasses.

2. Wet the sky area with the golden leaf brush and paint clouds in ultramarine.

3. Mask the roofs of the mill buildings with a paper mask and stipple trees using a pale wash of sunlit green and ultramarine with the foliage brush. Remove the mask and tidy the edges using the medium detail brush.

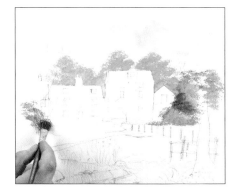

4. Stipple the trees on the right and the bush on the left with country olive and the foliage brush.

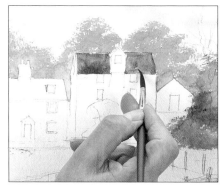

5. Paint the slate roof of the mill with the medium detail brush and a grey mix of ultramarine and burnt sienna.

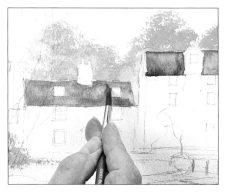

6. Paint the roof on the left with burnt sienna and a touch of ultramarine. Drop in raw sienna wet in wet.

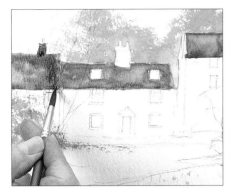
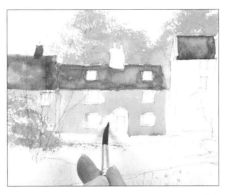
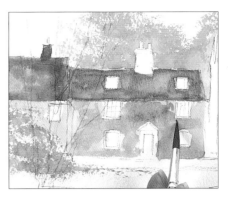

7. Paint the roof of the building on the left with burnt sienna and drop shadow in wet in wet.

8. Add cadmium red to the roof colour and water it down. Paint all the brickwork.

9. Drop shadow in wet in wet.

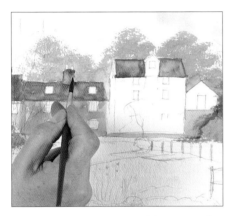
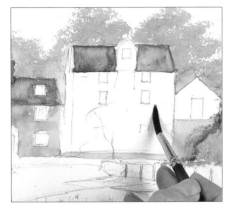
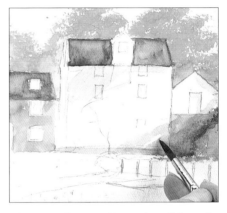

10. Paint half the building on the right with the brickwork mix, then use a thicker mix for the chimney stack on the left.

11. Paint a light wash of raw sienna on the mill and on the building on the right. Allow the paint to dry.

12. Use the medium detail brush and cobalt blue with a touch of shadow to paint the shadows under the eaves and from the gable and trees.

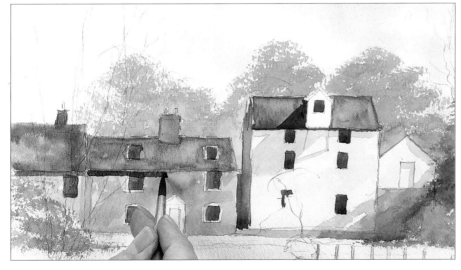

13. Use ultramarine and burnt umber to paint the shading on the mill roof, the dark windows and the shadow under the eaves of the building on the left.

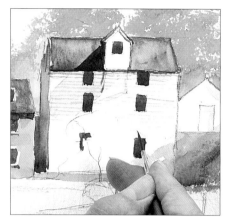

14. Use the half-rigger and a bluer mix of ultramarine and burnt umber to paint the weatherboarding on the mill.

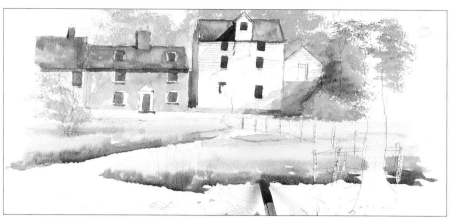

15. Make a light mix of raw sienna and sunlit green and paint the far stream bank with the large detail brush. Add a darker mix of country olive and burnt umber wet in wet as you come forwards. Paint the same succession of mixes on the right.

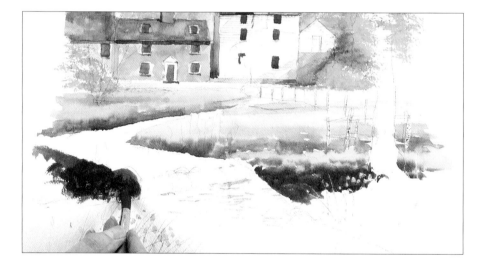

16. Add sunlit green as you come forwards, then midnight green and burnt umber at the base of the tree, up to the water's edge and on the other side of the stream.

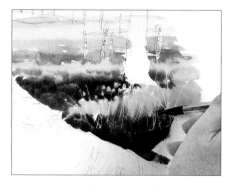

17. Paint cadmium yellow under the tree, and then take the large detail brush and flick the dark green mix up into it, wet in wet.

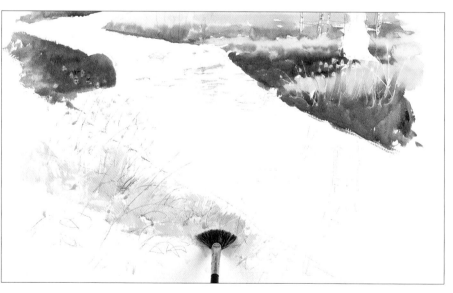

18. In the foreground, apply a light base colour, a mix of raw sienna and sunlit green, with the fan gogh brush.

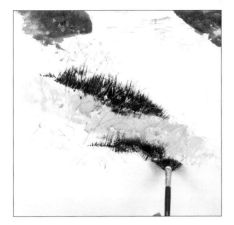

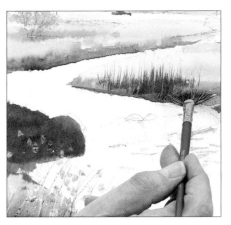

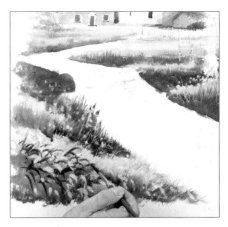

19. Flick up midnight green wet in wet into the lighter paint.

20. When the middle ground is dry, flick up grasses in midnight green, wet on dry.

21. Use the medium detail brush to paint grasses in midnight green among the masking fluid in the left-hand foreground.

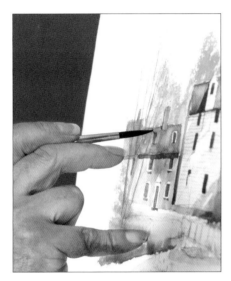

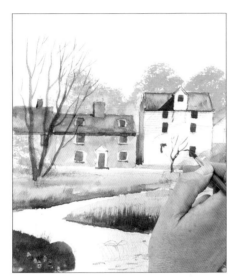

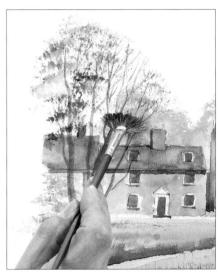

22. Paint tree trunks on the left with country olive and burnt umber. You can keep your hand still by supporting it with one finger against the easel as shown.

23. Paint in the middle tree in front of the mill in the same way.

24. Use the fan stippler and a mix of greens to paint the foliage on all the trees.

25. Take the large detail brush and a light mix of burnt umber and country olive and paint in the large tree trunk. Then use a darker mix to paint the shaded side.

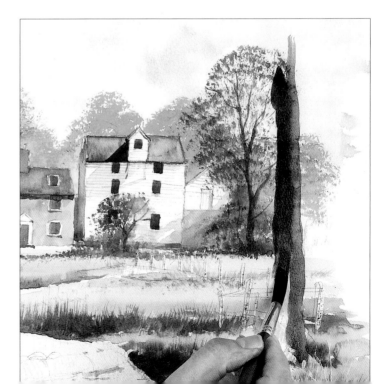

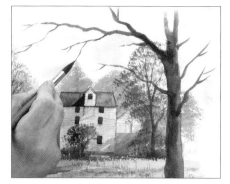

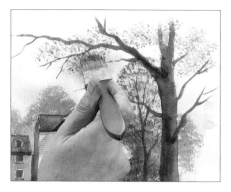

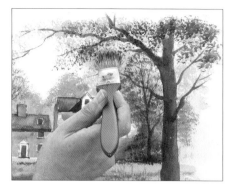

26. Paint the branches using the large detail brush.

27. Then use the golden leaf brush to stipple foliage in sunlit green.

28. Stipple country olive on top when the lighter green is dry.

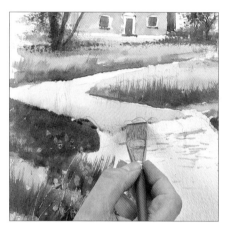

29. Paint the distant part of the stream using the 19mm (¾in) flat brush and ultramarine.

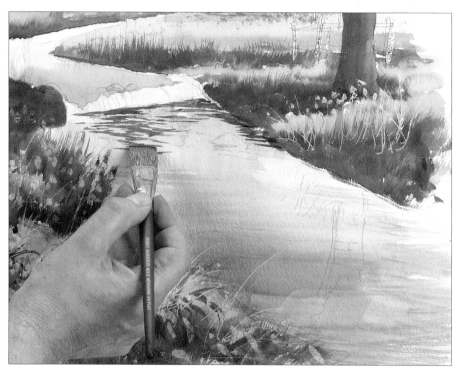

30. Paint a wash of ultramarine and burnt umber in the foreground, then add ripples with a darker, bluer mix of the same colours.

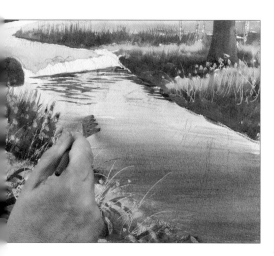

31. Paint ultramarine wet in wet over the browner mix in the foreground.

32. Still using the flat brush, mix country olive and burnt umber and drag reflections down into the water. Use the same brush and mix to paint ripples across the stream.

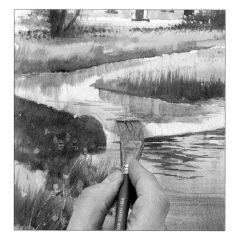

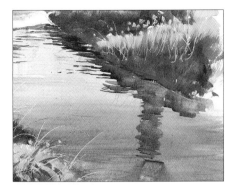

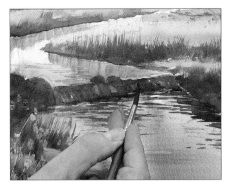

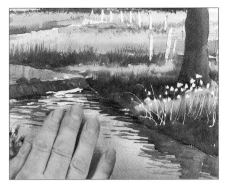

33. Still using the flat brush, paint country olive, burnt umber and ultramarine for the darks reflected from the right-hand stream bank.

34. Use the medium detail brush and a dark mix of country olive, burnt umber and ultramarine to paint the waterfall. Allow it to dry.

35. Remove the masking fluid over the whole area of the painting.

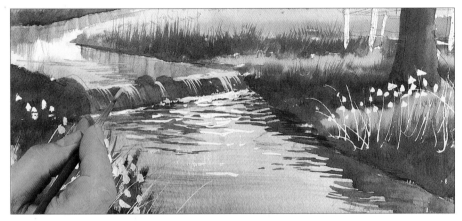

36. Mix white gouache with a touch of cobalt blue and add detail to the waterfall with a few downward strokes.

37. Paint the window bars with the half-rigger and white gouache.

38. Still using the rigger brush, paint details on the roofs using country olive with a touch of burnt umber.

39. Paint details on the mill roof with the half-rigger and ultramarine and burnt umber.

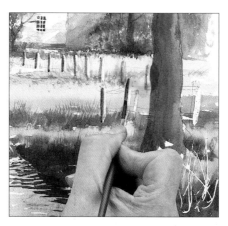

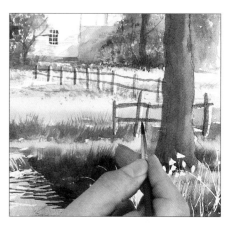

40. Paint the fence uprights with a light wash of raw sienna and country olive. Leave to dry.

41. Shade the left-hand sides with country olive and burnt umber, wet on dry.

42. Paint the horizontal bars of the fence with the same mix.

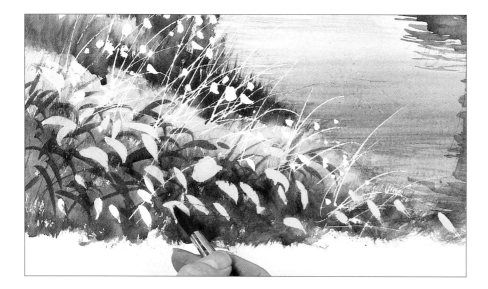

43. Apply a wash of sunlit green over the broadleaf plants in the foreground, using the large detail brush.

44. Paint raw sienna over the foreground grasses.

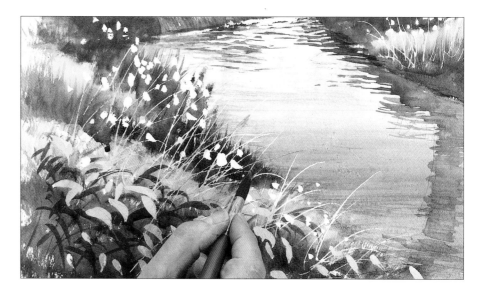

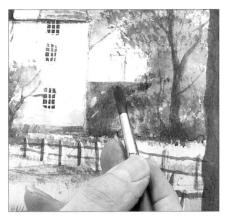 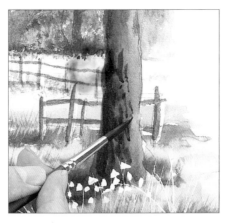 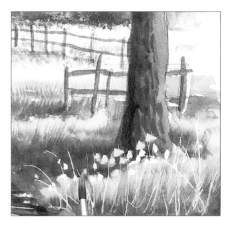

45. Use the medium detail brush to paint burnt sienna with a touch of cobalt blue on the building on the far right.

46. Paint the details in the large tree trunk using a dark mix of ultramarine, burnt umber and midnight green.

47. Paint the flowers under the tree with the medium detail brush and a wash of cadmium yellow.

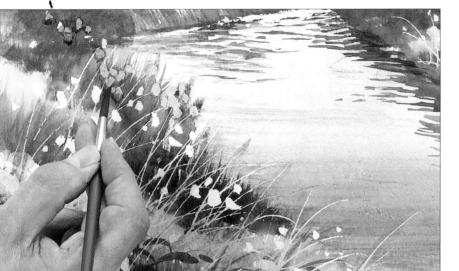

48. Paint the flowers on the left-hand bank with a thin wash of alizarin crimson.

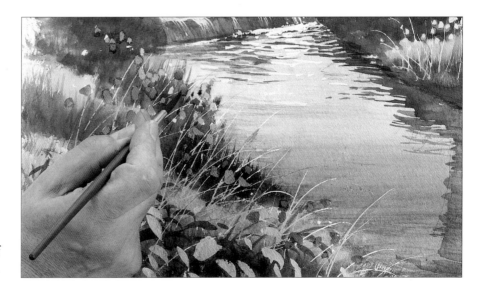

49. Drop in a stronger mix of alizarin crimson wet in wet.

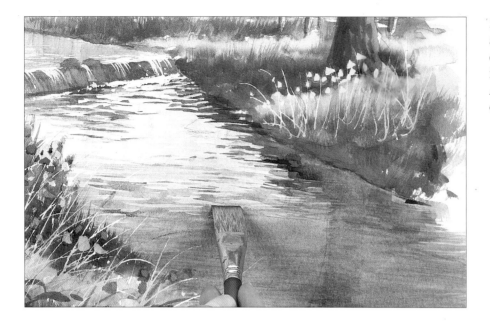

50. Make a mix of ultramarine and midnight green and wash it over the water in the foreground using the flat brush. Add ripples with a darker mix of the same colours.

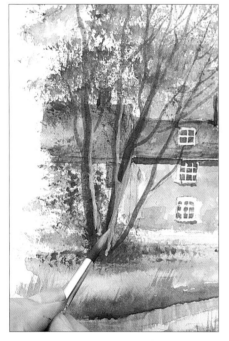

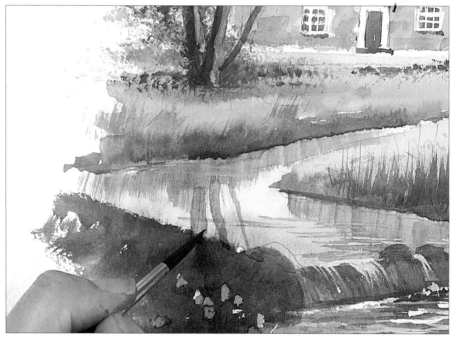

51. Use the medium detail brush to paint raw sienna mixed with white gouache on to the sunlit side of the tree on the left.

52. Add a reflection of this tree using burnt umber and country olive.

Opposite
The finished painting
370 x 510mm (14½ x 20in)
Although this painting is predominantly green, this is balanced by the warm colours of the mill house and the splash of colour in the foreground flowers.

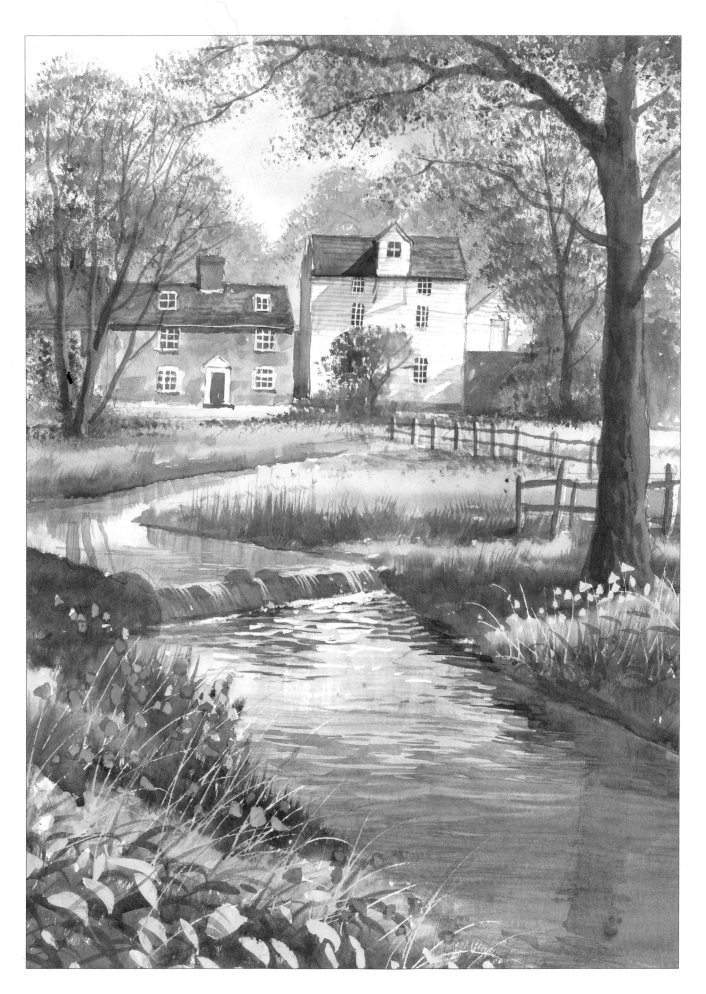

Index

Highland Retreat
535 x 335mm (21 x 13¼in)
*This painting owes a lot to the
credit card technique, creating
texture in the rocks and mountains
which is contrasted by the stillness
of the loch.*